Roy Lichtenstein:

MURAL
WITH
BLUE
BRUSH-
STROKE

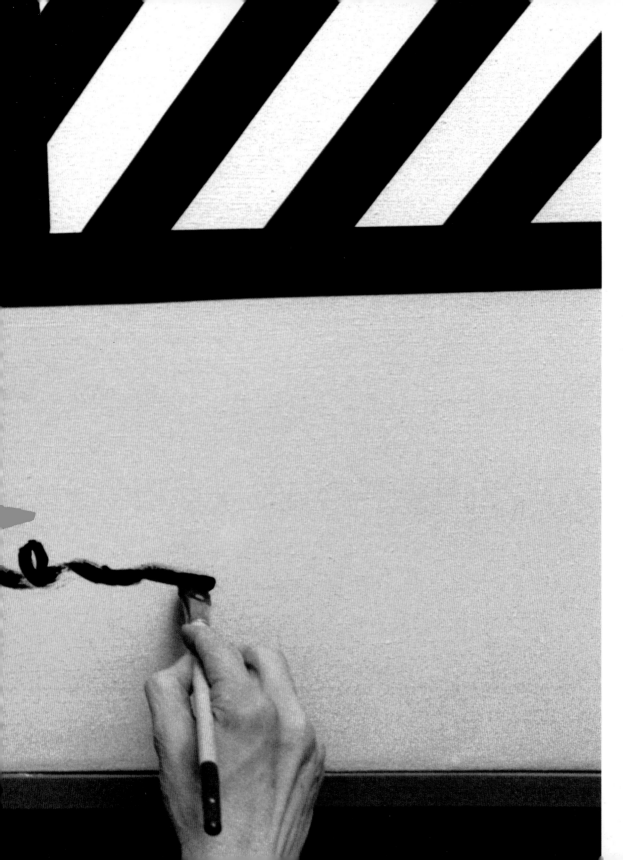

Roy Lichtenstein:

MURAL
WITH
BLUE
BRUSH-
STROKE

Essay by
Calvin Tomkins

Photographs
and interview by
Bob Adelman

Harry N. Abrams, Inc.,
Publishers, New York

Editors: Margaret Donovan,
 Anne Yarowsky
Designer: Samuel N. Antupit

Photo Researcher: Sally Henderson
Text Editor, interview: Susan Hall
Design Assistant: Doris Leath

Library of Congress Catalog
Card Number: 87–072175
ISBN 0–8109–1296–1 (cloth)
ISBN 0–8109–2356–4 (paper)

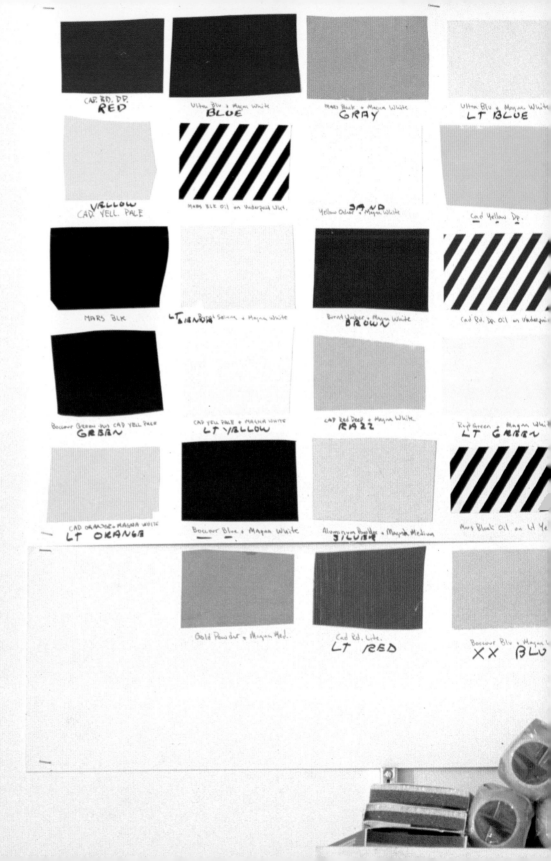

CONTENTS

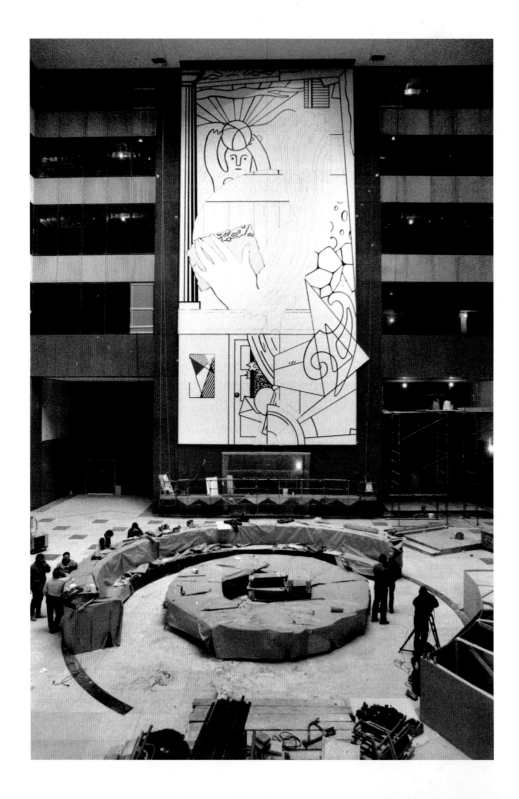

BRUSHSTROKES

The Equitable Life Assurance Society of the United States has hooked a big one, no doubt about that. Roy Lichtenstein's MURAL WITH BLUE BRUSHSTROKE dominates the atrium lobby of the company's new building in midtown Manhattan and imposes itself on the eye of the beholder on the sidewalk outside. Five stories high, it is one of the largest public art works in the city, an indelible sight, a permanent monument (as permanent as anything gets in New York) to Pop Art, that irreverent style whose name once seemed a synonym for evanescence. Lichtenstein, whom a *New York Times* critic once identified as "one of the worst artists in America," has emphatically confirmed here his status as an American master, universally accepted and almost universally admired. And yet the work, on at least one level, is a joke. I am reminded of a statement by H. L. Mencken: "As an American, I naturally spent most of my life laughing."

A surprising number of the original Pop artists have passed the test of time. Ordinarily in art history, an aesthetic movement shakes down to two or three major talents and a list of followers, but the Pops, like the Abstract Expressionists who preceded them, have done considerably better than that. Claes Oldenburg, James Rosenquist, George Segal, and Jim Dine continue, twenty-five years after their emergence, to operate at or near the front ranks of contemporary art, while Robert Rauschenberg and Jasper Johns, the precursors and progenitors of Pop, are our living old masters. No current reputation, however—not even the late Andy Warhol's—looks more secure than Lichtenstein's. During a quarter century of unflagging productivity, his work has commanded steadily increasing respect from critics and curators and steadily escalating prices from collectors. A new Lichtenstein painting sells for about one hundred and fifty thousand dollars these days, and one of his comic-strip

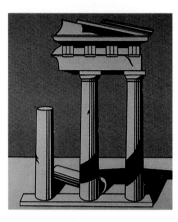

Above:
GIRL WITH BALL, 1961. Oil on
canvas, 60½ × 36½″

Below:
TEMPLE II, 1965. Oil and
magna on canvas, 94 × 128″

8

paintings from the 1960s recently brought seven hundred and ninety-two thousand in a Sotheby's auction. Lichtenstein's works come in series—he will often do forty or more paintings using the same general subject matter before moving on to something different—and some series have not been greeted as enthusiastically as others. The Mirror paintings that he did between 1970 and 1972—paintings of mirrors that reflect nothing but patterns of light and shadow, and which are the closest he has come in his post-1961 work to pure abstraction— were hard to sell at first, and so were the Entablatures, meticulous renderings of classical architectural design motifs. Collectors and museum curators learned to love even these somewhat difficult Lichtensteins, though; the consensus seems to be that there has been no negligible period in his career, no incidence of a falling off in quality or conception.

A number of those earlier periods in his work are recapitulated in the Equitable mural. The red, white, and yellow beach ball in the upper left corner recalls GIRL WITH BALL, one of his first Pop images (it was painted in 1961), which he appropriated from a long-running newspaper ad for a resort hotel in the Poconos; in the mural, however, the ball is being caught by a stylized male figure straight out of a drawing by Fernand Léger. The ball's topmost, yellow segment also functions as a rising sun, its painted rays fanning out in a sky whose diagonally striped shading brings to mind the Lichtenstein Landscape paintings of the mid-1960s. Other images or fragments of images refer to FOOT MEDICATION, KNOCK KNOCK, and other early Pop icons; to the Temples, the Entablatures, and the Artist's Studio paintings of the sixties and seventies; and, most prominently of all, to the Brushstroke series in which he parodied the impetuous style of certain Abstract Expressionists by devoting entire paintings to enlarged simulations of their brushwork, complete with dripping paint. The world's biggest

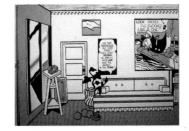

ENTABLATURE, 1974.
Oil and magna on canvas,
60 × 90″

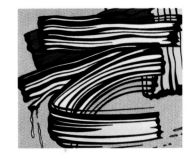

Above:
ARTIST'S STUDIO—LOOK
MICKEY, 1973. Oil and magna
on canvas, 96 × 128″

Center:
LITTLE BIG PAINTING, 1965. Oil
and magna on canvas, 68 × 80″

Below:
YELLOW AND GREEN
BRUSHSTROKES, 1966. Oil and
magna on canvas, 84 × 180″

brushstroke descends like a waterfall through the upper two-thirds of the mural, touching or skirting a score of other compositional motifs. It performs a grandly unifying function, and not for Lichtenstein's art alone. Other artists whom he admires, besides Léger, are here: Matisse (a green, plantlike shape suggests the paper cutouts of Matisse's last years); Braque (a brown baluster that echoes early Cubism); Jackson Pollock (a school composition book whose squiggly black-and-white design refers to the drip paintings); and living contemporaries such as Ellsworth Kelly (pure-color abstraction), Jasper Johns (flagstone-shaped forms), and Frank Stella (French curves and other draftsman's tools). The blue brushstroke terminates at the Entablature that bisects the mural horizontally, creating a division that echoes the architectural detailing of the lobby in that it lines up with a row of windows on either side of the mural. It also echoes (perhaps inadvertently, I thought at first) the compositional division of certain Renaissance and later religious paintings, the most famous of which is Michelangelo's *Last Judgment* in the Sistine Chapel. I was planning to ask Lichtenstein about this at some point during our recent conversations, but he brought the subject up himself, observing in his offhand manner that he seemed to have put Matisse, Léger, Kelly, and Johns in "heaven" and Stella and Braque largely in "hell." The reference *was* intended, then? It was, said Lichtenstein, "but in a pretty removed way." Confronted with a very large vertical space to fill (sixty-eight feet high by thirty-two feet wide), he had first intended to "do different kinds of sky at the top, and then different kinds of water in the middle, and different kinds of land at the bottom. I got the sky in, but the rest didn't turn out that way. But I guess I also had a sort of religious or patriotic idea of sky at the top. I would make it as though it were a religious painting, a pompous composition."

9

That *as though* is important. Lichtenstein always works at one or more removes from his subject matter. His early Pop paintings of kitchen appliances and consumer products were not modeled on the objects themselves but on the printed reproductions of them in newspaper and magazine ads, or in the yellow pages of the telephone book. His versions of other artists' work were all based on the way that work looked in printed, art book reproductions. Approached in 1984 to paint a mural for Equitable, he subjected the whole idea of public murals to the workings of his ironic intelligence and came up with an antimural. Murals are supposed to have a theme, or to make a statement on some large issue of the day. Take, for example, Thomas Hart Benton's multipanel mural *America Today*, which now hangs in the long corridor that leads to the Equitable lobby. Painted in the early 1930s, recently purchased by Equitable and painstakingly restored, it depicts, according to its accompanying label, "the economic and social life of the nation on the eve of the Depression." Lichtenstein's mural makes a rather different statement. "I tried to construct it the way I would if I were saying something important," he told me. "It has no theme whatever, but it seems to be saying something." What it really says is "Public Mural!" It is a mural that pokes fun at murals, at modern corporate pretensions, and at the architectural space it inhabits. A woman's hand holding a sponge appears to be washing away a part of the mural itself, and in the process uncovering a row of windows that lines up with the real windows on either side. The holes in a slice of Swiss cheese at the far right relate to the holes in the sponge; also to the Johns flagstones, to Jean Arp, and to the all-too-familiar "negative volumes" in a hundred public sculptures by the late Henry Moore. The huge mural snaps and crackles with visual jokes, puns, and asides. Is it a sign of maturity or decadence that a major American corporation can

enthusiastically accept a work of this kind, an *as though* mural that subverts its own supposed function? Equitable's ruling echelon is said to have lodged only one objection to the work. The painted door in the lower section came from an early Lichtenstein comic-strip painting called KNOCK KNOCK, and those two words, with their accompanying star-shaped symbols (to connote the sound of someone knocking on the door's other side), were part of the image. For reasons that are unclear, some Equitable officials were unhappy about including "Knock Knock." Lichtenstein was unhappy about their unhappiness, but in the end he deleted the offending words.

Lichtenstein's audience has come around to his own benevolently sardonic view of things during the last quarter century. This is the great age of unbelief, and no artist surpasses Lichtenstein in celebrating the antiheroism of modern life. What seems truly remarkable, though, and difficult to explain, is how well his mural succeeds on the more obvious level of a spectacular visual event. It is enormously beautiful. Lichtenstein has traveled a long way from the severely reduced palette of his 1960s paintings, in which he limited himself to four colors, plus black and white. He used eighteen in MURAL WITH BLUE BRUSH-STROKE, and the chromatic balance is so subtle that there seem to be many more. The huge painting has a unity and a presence that we invariably look for in art and rarely find; it holds the space with complete authority, and Equitable's ruling echelon has every right to be proud of its foresight in commissioning it. There is nothing *as though* about its success.

Although Roy Lichtenstein's work is not even remotely autobiographical, the same combination of authority and ironic distance that characterizes the work also applies to his personal life. People who feel they are close friends of his often say that they do not know him

11

very well. Lichtenstein himself sometimes says he has no real life outside the studio. (When his friend Frederic Tuten was asked to write a book about him, the two of them decided they would have to invent a private life from scratch; eventually they dropped the whole project.) Shy with strangers, uncomfortable at parties, he manages nevertheless to entertain casual dinner companions with a dry, self-deprecating wit that seems thoroughly self-assured. He keeps up. He reads nothing but science journals—science is virtually his sole area of interest outside art—but somehow he seems to know what is going on in the world. Recently he and his second wife bought a place in Manhattan, after fifteen years of a relatively isolated country life on Long Island. They are seen more frequently at art world openings and parties as a result, but not much more frequently, and Lichtenstein continues to live a relatively isolated life in the city. When the "Today Show" wanted to interview him prior to the unveiling of his Equitable mural, he declined. He stays trim by jogging (his only sport; he used to play tennis, but he gave it up), and he looks a decade younger than his chronological age of sixty-three. In recent years his rather boyish, blond good looks have been succeeded by a craggier, more distinguished appearance, which he does nothing to enhance. Travel, which his wife Dorothy dotes on, interests him hardly at all. He hates lying on beaches, and he does not know what to do with himself when they go to the beach house on Captiva Island, in Florida, that Dorothy purchased some years back. Lichtenstein is a compulsive worker, really content only when he can spend six hours a day in his studio. He works without apparent anxiety or strain, according to Olivia Motch and James de Pasquale, two assistants who have been with him for more than a decade, and who have learned to interpret wants of his that are conveyed with a minimum of verbal information. There is no monster ego at work in this studio. Lichtenstein

usually knows what he wants to do and how to do it, but he does not seem to have an overwhelming belief in its importance. Sometimes he gives the impression of a man who thinks it might all disappear someday—work, career, his place in the art history books that have already been written. "The work is so acceptable now," he said to me. "I hate to think of it as being housebroken. There's still some nonacceptance, of course, but it is sort of amazing that people have taken to it this way. I guess what I really worry about is that someday *I'll* start to think it's dumb."

Lichtenstein's uneventful life and his subversive art seem out of phase. Can he really be as bland, as laid back, as genuinely nice a person as he seems? Are his inner contradictions subject to some form of implacable control? His mother once told a friend of his that he had been an ideal child—never in trouble, never demanding, always polite and well behaved. Lichtenstein himself thinks he must have been a little strange. "I felt that way, anyhow," he told me. "I did all the normal things, nominally. I mean, I would stand out there in the outfield and watch the fly ball hit the ground. Actually I was good at swimming." He grew up on the Upper West Side of Manhattan, in a fairly well-to-do household. His father was a real estate broker who specialized in managing garage properties and parking lots. Young Roy went to public school until he was twelve; then he went to the Franklin School, a private academy on West Eighty-ninth Street, from which he graduated, with mediocre grades, in the spring of 1940. As a boy he had been very interested in drawing. This had been superseded for several years by a fascination with science, brought on by his getting a chemistry set one Christmas, but when he was fifteen he made a firm decision to be an artist rather than a scientist. There

were no painting classes at Franklin then, but he painted a lot on his own during his last two years there, and immediately following his graduation he enrolled in the Art Students League. He studied that summer under Reginald Marsh—nominally; he says Marsh was on hand to give criticism about fifteen minutes a week. His parents were quite supportive of his decision to be an artist. They didn't see how he was going to earn a living that way, though, and they insisted that he go to a real college, where he could get a liberal arts degree that would qualify him to teach. (Lichtenstein would have much preferred to stay on at the League, or some other studio art school.) The college he chose was Ohio State University, which had a large and well-established, degree-granting art department.

"I had no idea what art was then," he recalls. "I was very foggy about the whole thing." As it happened, there was a teacher at Ohio State who was very clear about the whole thing. This was Hoyt L. Sherman, engineer, painter, author of *Drawing by Seeing*, disciple of John Dewey, and inventor of a course based on rigorous drawing as the key to visual perception. "Sherman developed something called a flash room," Lichtenstein told me, "a darkened room where images would be flashed on a screen for very brief intervals—about a tenth of a second. Something very simple to start, maybe just a few marks. And you would have a pile of paper, and you'd try to draw it. You'd get a very strong afterimage, a total impression, and then you'd draw it in the dark—the point being that you'd have to sense where the parts were in relation to the whole. The images became progressively more complex, and eventually you would go out and try to work the same way elsewhere—would try to bring the same kind of sensing to your drawing without the mechanical aid of the flash room. Sherman didn't think he could make people into artists by this method, but he did think that the kind of

seeing that made art could be engendered at whatever level a person was able to operate on. He thought the artist saw things in a unified way, had a kinesthetic response to the unity of the image, and he was interested in conveying this experience at a mass level. He taught dental students and football players, hoping to increase their powers of perception. It was a mixture of science and aesthetics, and it became the center of what I was interested in. I'd always wanted to know the difference between a mark that was art and one that wasn't. Sherman was hard to understand, but he taught that the key to everything lay in what he called perceptual unity."

Midway through his junior year at Ohio State, in February 1943, Lichtenstein was drafted into the army. He served for nearly three years, the last two of which were spent as a private first class in an engineers battalion of the 69th Infantry Division in England, France, Belgium, and Germany. "We were winning the war quite easily at that point," he told me, implying that his service was neither perilous nor particularly interesting. After V-E Day he spent three months in Paris, studying French language and civilization in a G.I. course at the Cité Universitaire, but when word came early in 1946 that his father was dying he was furloughed home and discharged. He reentered Ohio State soon after the funeral. Because he had accumulated so many academic credits during his army training, he was able to graduate that June. The art department thought well enough of Lichtenstein to offer him a teaching job there while he worked for his master's degree; he ended up staying on as an instructor at Ohio State until 1951.

Lichtenstein got married in 1949, right after receiving his M.F.A. degree. His bride was Isabel Wilson, who had grown up on a farm in western Ohio; when he met her she was the codirector, with Algesa O'Sickey, of a small art gallery in Cleveland. Lichtenstein was a

professional artist, himself, by this time, having exhibited work in several group shows in the Midwest. In 1951 he had his first solo exhibition in New York City, at the Carlebach Gallery on Madison Avenue. His work then was semiabstract, derivative (of Picasso and Klee, primarily), and rather peculiar. Images of knights in armor and medieval castles could be discerned in rather meticulous, Klee-influenced compositions. He sold enough of these at the Carlebach show to pay for the framing and shipping.

The huge postwar enrollment of college students under the G.I. Bill was starting to taper off by 1951, and Lichtenstein's appointment to the Ohio State faculty was not renewed. Isabel had a job then as a decorator in Cleveland, so they moved there and stayed for the next six years. Lichtenstein had a number of temporary jobs in Cleveland. He worked on product and process development for the Republic Steel Corporation (he had taken engineering drawing courses at Ohio State); he did window display work for Halle's department store; he did drafting work for architectural firms. He would work for six months or so, then take several months off to paint. "I was painting cowboys and Indians then, historical things," he told me. "I was taking the kind of stodgy pictures you see in history textbooks and redoing them in a modern art way." These parody-western scenes, done in a deliberately childish pastiche of the modernist idiom, had superseded the "medieval" pictures he showed at Carlebach in 1951. "It was making a comment on other people's graphic work, which I'm still doing," he said, "and it was ironic, although not ironic enough, I guess. I had no real thoughts about using popular imagery then. I probably disdained popular culture in a professorial way—thought comic books were awful. My first real sense of it came in 1958, when I did a painting of a ten-dollar bill in a style somewhere between Cubism and Expressionism, which

was where everybody was located then. That was when I first got the idea of doing really simpleminded pictures that would look inept and kind of stupid, and the color would look as though it wasn't art. Of course Larry Rivers had done things like that, and Rauschenberg had done things, and Johns, and Richard Hamilton in England, none of which I was terribly aware of. But those things had overtones of Expressionism and Dada. To be completely commercial-art-looking in an unartistic way didn't really occur to me until 1961. Even so, it's amazing how much those historical pictures I was doing in the mid-fifties look like the ones I'm doing now."

Lichtenstein continued to show his work in New York City throughout the 1950s. He had four shows at the John Heller Gallery between 1952 and 1957 and one at the Condon Riley Gallery in 1959. There were brief reviews in *Art News* (including a favorable mention by Fairfield Porter), but nothing to launch a career. Meanwhile, the various temporary jobs in Cleveland were not leading anywhere, and the pressures of a growing family—David Hoyt Lichtenstein was born in 1954, Mitchell Wilson Lichtenstein in 1956—convinced their father that he should go back to teaching. The possibility of making a living as an artist seemed as remote to him then as it had to his own parents. He sent out a lot of applications and resumés, and when the State University of New York at Oswego came through with an offer of an assistant professorship in the art department, he took it. Lichtenstein taught at Oswego, a small upstate college near Lake Ontario, from 1957 to 1960. In that period he quit painting mock-historical pictures and adopted an Abstract Expressionist style—the prevailing manner internationally. As Diane Waldman pointed out in her 1971 monograph on him, the year 1957 was a remarkably late date to take up Abstract Expressionism, "considering the fact

that the high point of the movement had long since passed and that Johns had already created some of his major paintings." In an interview published in the Waldman book, Lichtenstein explained that, living in Ohio and then in upstate New York, he had not been in close touch with current art world developments. "Most of what we saw was in reproduction," he said.

His own abstractions "did not bring much new information to the scene," he says, and they attracted little attention when he showed them at the Condon Riley Gallery, in New York City, in the late spring of 1959. Something new *was* going on, though, in a group of paintings that he did not exhibit anywhere. Images from the comics began appearing in his otherwise abstract compositions. Lichtenstein thinks that the impetus for this probably came from Willem de Kooning's Woman paintings of the early 1950s, pictures in which references to female faces and bodies emerged from the turmoil of agitated brushwork. Lichtenstein's variation was slyly irreverent—having Mickey Mouse and Donald Duck invade the emotionally fraught and by this time virtually sacrosanct "arena" of Abstract Expressionism—but he was not confident enough to show them publicly. Not one of these pictures survives; he destroyed or painted over them, and four or five drawings are all that remain from this transitional phase of his career.

In the spring of 1960, Lichtenstein was invited to join the art department of Douglass College in New Jersey. Douglass was then the female branch of Rutgers, the state university, and according to Lichtenstein the offer came just in time—a lot of new things were going on in the New York art world, less than an hour away; if he had stayed in Oswego he would never have become a part of them. Surprisingly, the Rutgers art department itself was a seedbed of innovation just then. Allan Kaprow, who taught art history at the men's college, and who was making a name for himself as an avant-garde artist and intellectual gadfly on the

New York art scene, had exerted a galvanizing effect on several of his students, and particularly on Robert Whitman and Lucas Samaras, both of whom were making significant contributions to the Happenings movement, which Kaprow and others had launched in 1958. He knew a lot of artists, dealers, and other participants in the rapidly changing downtown art scene. In addition to Kaprow, the Rutgers art faculty included Bob Watts and Geoff Hendricks, two young artists who were active in the Fluxus movement, which had some points of affinity with the Happenings. All of them knew George Segal, who was not on the faculty but who lived nearby on a chicken farm that he and his wife ran mainly as a means to support his career as a sculptor. The Segals' farm had become a sort of weekend retreat for a large and amorphous group of young New York artists and their friends. Claes Oldenburg, newly arrived from Chicago, remembers feeling uncomfortable the first time he went there because he was the only man wearing a white shirt and a necktie. "It was a totally heterogeneous group," according to Diane Waldman, who was then a young curator at the Guggenheim Museum; she and her artist-husband, Paul, went often to the Segals' and met most of the young artists there, including Lichtenstein. "No schools, no hierarchies, and lots of fun. They all had the feeling that the art world was about to change, that Abstract Expressionism was no longer going to be so dominant. It was a very open scene, and the interaction was social rather than aesthetic."

The first, impromptu Happening, loosely organized by Kaprow and even more loosely interpreted by his friends, had taken place during a picnic at the Segals' in the spring of 1959. It involved about a dozen people, who jumped through plastic sheets, sat in chicken coops rattling noisemakers, painted a collective canvas, and performed a variety of slow, ritualistic movements. That fall, Kaprow staged his *18 Happenings in 6 Parts* at the Reuben Gallery in New York City, the event that gave the movement its name; the season also

witnessed the first performances by Oldenburg, Jim Dine, Red Grooms, and Bob Whitman. These plotless, nonverbal theatrical events by visual artists had a variety of antecedents: the Dada and Futurist provocations in the period immediately following the First World War; circus and carnival acts; early Hollywood silent comedies; the new choreography of Merce Cunningham and Paul Taylor, which made use of "everyday" movements like walking and sitting down; the ideas of John Cage, a widely influential composer and teacher who sought effectively to break down barriers between art and life; the "combine" paintings of Rauschenberg, whose materials included the most outlandish found objects and street junk. According to Kaprow, the movement's most vocal theorist, an even more direct source was the work of the late Jackson Pollock. In an article called "The Legacy of Jackson Pollock" that appeared in *Art News* in 1958, Kaprow argued that the quality of Abstract Expressionist painting had fallen off since Pollock's death two years earlier, and that the real implications of Pollock's breakthrough had been missed. Pollock's paintings were really "environments," Kaprow wrote, and Pollock's heirs should now learn to go beyond paint and canvas in order to immerse themselves in the environment of everyday life. The future direction of "action painting," he argued, was more action and less painting.

Lichtenstein once identified Happenings as "the greatest influence on my work." He saw a lot of them, thanks to Kaprow, and, while he was never tempted to stage one or perform in one, there is no doubt that their anarchic spirit helped to shake up the professor in him and to release the iconoclast. "Kaprow made it clear to me that my work did not have to look like art," he said, "meaning all that business of texture and modulated colors that people think of as art. Of course, the Ab-Ex people had cultivated a mean, dirty look that wasn't supposed to

look like art, either. Pollock with his cigarette butts and footprints in the paint. But pretty soon everybody was doing that, and so it looked like art again. I wanted to say something that hadn't been said before, and it seemed to me that the way to do that was to make it look industrial—in my mind the statement was always more industrial than American. This was the way the world really looked, after all. The real American architecture is McDonald's and not Mies van der Rohe."

His own breakthrough came about in the spring and summer of 1961, and it involved neither found objects nor "environments" but found images—printed images from the lower depths of commercial art. Kaprow recalls the moment vividly. "I'd taken my family over to the Lichtensteins' house—our kids were about the same ages as theirs—and when the mothers and children went out in the car to buy refreshments, Roy and I started to talk about teaching—how to teach students about color. Roy was very caught up with Cézanne then. The car came back, and the kids all had sticks of Bazooka Double Bubble Gum, the kind that had comics printed on the wrapper. I pulled one of those wrappers out flat, and I remember saying to Roy, sort of archly, 'You can't teach color from Cézanne, you can only teach it from something like this.' He looked at me with the funniest grin on his face. 'Come with me,' he said. I followed him upstairs to his studio, which was on the second floor of the house. He lifted up a lot of abstract canvases that were tacked to the wall and showed me the one at the back, which was an abstract painting with Donald Duck in it. I was sort of nonplussed at first. Two seconds later I let out a big guffaw. It was as though he had confirmed what I'd just been saying."

A story that has gained currency over the years is that Lichtenstein started painting

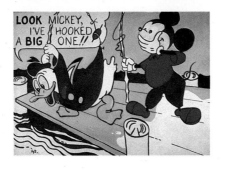

Look Mickey, 1961.
Oil on canvas,
48 × 69"

the comic-strip pictures because his two sons challenged him to do so. Like the story about the French boys who climbed down a hole in a field to rescue their dog and accidentally discovered Lascaux, this one has some truth in it, but not much. Lichtenstein had been sneaking veiled references to the comics into his paintings for a couple of years; with Kaprow's active encouragement, he now began to use such images straight, without any "art" context. Look Mickey, the first one, painted soon after that momentous conversation with Kaprow in 1961, is so close to the original bubble-gum wrapper that Kaprow held up that the only perceptible difference is its size. Lichtenstein drew it freehand on the canvas and then filled in the outlines with raw primary colors. He did many more that summer, and the elements of his famous style fell into place: the painted-on dots to simulate the Benday dot screen that commercial printers use to achieve half-tones without changing color; the thick black outlines around each image; the radical croppings and foreshortenings used to intensify the composition; the "industrial" tonality that he got by careful adjustment of a few basic colors — "supermarket colors," as he described them, acid yellow, dull green, purplish blue, and a standard red "like a *Life* magazine red," plus black and white. The big, bold images from love comics and war comics and from cheap commercial ads that made Lichtenstein's reputation in the early sixties differed in many subtle and not so subtle ways from their printed sources, although few people were aware of this at the time. He eliminated details ruthlessly, pushing his images at times to the edge of abstraction. Although he began in 1964 to use an opaque projector to establish the basic outlines for his paintings, the drawings that he projected on the canvas were always his own drawings, adapted with many shifts and alterations from the source, and the projected image was subject to many further alterations. His simulation of commercial graphics was so

convincing, however, that most people assumed he simply copied his images directly. This infuriated some critics. "A painting by Lichtenstein is at once ingenuous and vicious, repulsive and modish—the latest sensation," Max Kozloff wrote in *The Nation*. Rauschenberg and Johns both hated the comic-strip paintings when they first saw them in the back room at the Castelli Gallery. Rauschenberg changed his mind almost immediately, but it took Johns several months to accept them. For Lichtenstein, the new paintings "seemed to say everything I needed to say about the present time. I just felt hugely exhilarated."

The spontaneous convergence of low culture and high spirits that gave rise to Pop Art came as a surprise to the artists involved, none of whom knew what the others were doing. Andy Warhol was stunned when he saw Lichtenstein's paintings at Castelli's; he had been making paintings with images of Dick Tracy, Sluggo, and other cartoon characters in them, paintings that retained elements of Abstract Expressionist technique and which, for that reason, did not come across as aggressively as Lichtenstein's. Ivan Karp, Leo Castelli's codirector, saw James Rosenquist's work for the first time about three weeks after he saw Lichtenstein's; he went to a loft way down on Coenties Slip to look at some ornamental stonework that the loft's owner (Rosenquist) said he had picked up from the site of a building that was being torn down, and there on the wall were large paintings done in a fragmented billboard style. Karp told Richard Bellamy about them, and Rosenquist surfaced at Bellamy's Green Gallery a month after Lichtenstein's first show at Castelli's. Oldenburg had already shown at the uptown Martha Jackson Gallery by then, and his *Store*, a Lower East Side storefront converted into a showcase for his painted plaster and papier-mâché replicas of cut-rate merchandise, had been the sensation of the 1961–62 season downtown. Of all that early

23

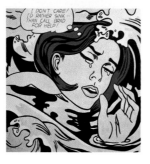

DROWNING GIRL, 1963.
Oil and synthetic polymer
paint on canvas,
67⅝ × 66¾″

Pop work, though, it was Lichtenstein's that aroused the most intense hostility. Oldenburg's giant soft hamburgers and toothpaste tubes, Warhol's Brillo boxes and Campbell soup cans, Rosenquist's gigantic coils of spaghetti struck most observers at the time as more or less harmless jokes, good-natured and not a bit serious. "It's nice to see those young fellows having a good time," Robert Motherwell is reported to have said; his generation of Abstract Expressionists knew that real art was serious. Lichtenstein's pictures lacked this kind of innocence. There was something very cold about them, an ironic distance between the highly emotional subject matter ("I don't care!" the DROWNING GIRL's text block read, "I'd rather sink—than call Brad for help!") and the impersonal, commercial-art handling. His pictures were threatening to art in somewhat the same way that Marcel Duchamp's readymades had been, nearly half a century earlier; if this was art, what wasn't? They seemed to sneer at the whole notion of originality in art, partly because so many viewers assumed they were exact copies. The fact that the media picked up on Lichtenstein's work so fast, and that ad agencies began using Lichtenstein-inspired comic-strip images and text balloons to sell real products, only served to confirm the threat. By basing his art on some of the most despised aspects of American culture (despised by intellectuals, that is), Lichtenstein seemed to go beyond the acceptable limits of bad taste. He actually managed to shock people.

In retrospect it is clear that his ambitions were always highly traditional. Lichtenstein never thought that what he was doing was antiart. Anti-Europe, maybe, in the sense of making something that looked industrial and "not like art," but in his mind it always *was* art. Contemporary advertising had created a landscape made up partially of the desire to sell products, he said in a 1966 interview, and this was the landscape he wanted to portray. He was

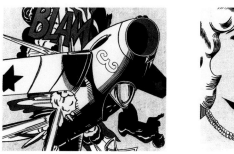

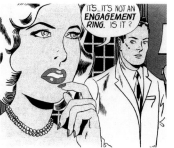

Right:
BLAM, 1962.
Oil on canvas,
68 × 80″

Center:
THE ENGAGEMENT RING, 1961.
Oil on canvas,
67¾ × 79½″

THE REFRIGERATOR, 1962.
Oil on canvas,
68 × 56″

not interested in making a social comment on it, except perhaps incidentally. While conceding that "A minor purpose of my war paintings is to put military aggressiveness in an absurd light," he went on to insist that "this is not what my work is about." His work, he said, was about how to construct paintings; that was how he envisaged it, and, once the initial shock of his subject matter wore off, that was how his rapidly growing army of admirers came to accept it.

Impervious to the hostility of critics and some artists, a number of collectors were avid for Lichtenstein's Pop paintings from the start. His first solo show at Castelli's, in February 1962, was sold out before the opening. Prices were ridiculous by current standards—$1,000 for BLAM, $1,200 for ENGAGEMENT RING, $800 for THE REFRIGERATOR. But the purchasers were Richard Brown Baker, Giuseppe Panza, Robert Scull—people who had helped to make the market for Abstract Expressionism and who were becoming in the 1960s a major factor in contemporary art, superseding the critics and museum curators in their ability to respond to new work. Lichtenstein's prices went up rapidly after the show, and they probably could have gone up a lot faster. Three years later the German collector Peter Ludwig fell in love with M-MAYBE, a painting of a lovelorn blond girl that Lichtenstein had decided to keep for himself. Ludwig went to Castelli and asked what sort of price might induce the artist to part with it. "Oh, maybe twelve thousand dollars," Castelli said, casually doubling the going rate. Ludwig promptly offered Lichtenstein thirty thousand, and got the picture. The art market was a small place in those days, with no more than two dozen serious, habitual buyers of advanced contemporary work in the world. By 1964, though, Lichtenstein was able to quit teaching and devote himself exclusively to painting, and within another year or so he

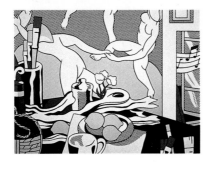

ARTIST'S STUDIO—THE DANCE,
1974.
Oil on canvas, 96 × 128″

was on his way to becoming one of the best-paid artists alive. His early fans had had no trouble convincing themselves that what he was doing was art. When he abandoned the comics and the consumer goods ads and started in on his versions of Picasso, Cézanne, Monet, and other landmarks in the history of modern art, the initial hostility to his work melted away. The critics soon discovered, in fact, that Lichtenstein was not only an artist but a formalist artist like Mondrian, for whom subject matter was relatively unimportant. Diane Waldman made an effective case for this reading in a 1969 Lichtenstein retrospective she curated at the Guggenheim Museum. In his subtle and complex playing off of color against color, form against form, and color against form, Waldman argued, Lichtenstein was a traditional artist—certainly as traditional as Kenneth Noland, Helen Frankenthaler, and the other so-called "color field" painters with whose abstract work Lichtenstein's was now perceived to have a close affiliation.

Lichtenstein's work from about 1965 on lent itself quite readily to this interpretation. Instead of continuing to make art out of low and despicable subject matter, he began subjecting various examples of "high" modern art to his cartoon style; the results seemed less threatening, and the formalist issues easier to discern. The increasing complexity of his technical means, moreover, and the skill and wit with which he took over other artists and art movements—Monet's cathedrals and haystacks, Matisse's studio interiors, Analytical Cubism, Futurism, Purism, Surrealism, Expressionism—and transformed them into Lichtensteins, served to locate his primary concern in the thoroughly familiar twentieth-century mainstream of art-about-art. As his palette expanded, from the original four colors (plus black and white) to the current repertoire of approximately twenty-five colors, including several delicate

pastels, his paintings became more ingratiating, the color harmonies more decorative. Having made his mark as the most outrageous of the original Pop artists, he became one of the most widely admired painters of his time.

His private life remained wholly private. Divorced in 1965, he largely took over the raising of David and Mitchell when their mother became incapacitated by illness. (She died in 1980.) In 1968 he married Dorothy Herzka, a Brooklyn girl who had worked for the Bianchini Gallery, and who looked, everyone said, just like the wide-eyed all-American girls in his love comics paintings. The Lichtensteins moved out in 1972 to Southampton, Long Island, where they settled down to a quiet, countrified life that was centered, for Roy, around his five or six hours a day in the studio, seven days a week. Paintings issued from the studio in measured profusion. He showed once a year at Castelli's, and virtually year round at galleries and museums throughout the United States and Europe. Museums vied with private collectors for the major works in each series. Graduate students wrote theses on his *oeuvre*. Lawrence Alloway, the critic who had promulgated the term Pop Art and who had written interestingly about other artists, produced a deifying monograph in the elephantine academic manner. The artist disappeared into his art.

Lately he has showed signs of reappearing. Nothing dramatic, of course, although the decision to buy property in Manhattan and to spend at least half the year living and working there probably qualifies as high drama in a life as calm as Lichtenstein's. Since the major retrospective of his work that opened at the Saint Louis Art Museum in 1981 and then traveled to eight other museums in this country, Europe, and Japan, Lichtenstein himself has been more of a presence on the international art scene. He completed his first public art

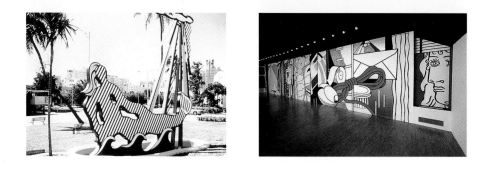

Right:
THE MERMAID, 1979.
Concrete, steel,
polyurethane paint,
palm tree, and water,
21′ × 24′ × 11′

Far right:
GREENE STREET MURAL, 1983.
Paint and collage on wall,
18′ × 95′8″

commission in 1978—a ten-foot, steel and concrete sculpture called MERMAID in Miami Beach (like his Explosions and his coffee cup sculptures of the 1970s, this one carries into three dimensions his preoccupation with giving solid form to ephemeral events like smoke, or, in MERMAID, rays of sunshine falling on a female form). Large-scale public art is clearly a new direction that interests him. In 1983 he painted a ninety-six-foot-long mural on the wall of Leo Castelli's Greene Street gallery. This much-discussed painting, which is now covered by a plaster wall (Castelli talks of uncovering it sometime) turned out to be a warm-up for the Equitable commission. More commissions are brewing. Currently he is working on a sculpture of a girl's head—a "brushstroke head" made out of painted steel forms in the shape of brushstrokes—for a park in Barcelona. Meanwhile, he has been sought out and befriended by Julian Schnabel, David Salle, and other stars of an artist generation twenty years younger than his own. They respect the sustained quality of his career, and they are particularly impressed by his recent work, in which, according to Schnabel, he has been more willing to "let go" and take chances with color and form.

It seems quite possible that Lichtenstein's future career may hold some surprises for his many admirers, both young and old. Curiously enough, the element of humor that has been at the center of his aesthetic since the early sixties is rarely commented on or even acknowledged today. Everyone agrees that Lichtenstein is a serious artist, and a serious artist, it seems, cannot also be a humorous one. The same problem comes up in relation to Picasso, the twentieth-century artist whom Lichtenstein admires more than any other. The grotesque and bawdy humor that runs through so much of Picasso's work is an embarrassment to many critics, a gross inconvenience that they prefer to ignore. Critics who ignore the humor in Lichtenstein simply make themselves ridiculous. While Lichtenstein has often said that he is

not interested in making a social comment, his work does speak to and for its period with a wealth of shared references that few other artists can match, and most of these references contain barbed jokes. The antiheroism of modern life is one of his sustained themes, along with the ersatz, *as though* quality of our contemporary experience. Long before the French poststructuralist philosophers discovered that we were living in the age of simulacra—an age in which reality has been replaced by the signs and symbols that the omnipresent media uses to represent that reality—Lichtenstein based his art on the culture of reproductions. His trick was to make real art out of debased materials—comics, advertisements, and reproductions of works of art, reproductions whose effect is to falsify the original in almost every particular. Unlike the poststructuralists, Lichtenstein makes his point with a wit and a lighthearted intelligence that is thoroughly convincing. His irony, which keeps everything at one remove, is also the element that wins you over.

Look again at his MURAL WITH BLUE BRUSHSTROKE. One reason it is so exhilarating is that it makes us laugh in a salutary way. A public mural is a fairly silly idea, this one suggests, but absurdity lies all around us all the time, in the pretensions of artists no less than in the pomposity of corporations. Art is not going to save us from ourselves, or lead us resolutely into the future, or teach us about heaven and hell. It has been around for a long time, though, and there are worse things to look at. We can laugh at the sponge wiping away the mural, at the Swiss cheese that reminds us of Henry Moore, at the mini-retrospective of Lichtenstein's own career as the Master of Reproductions. It is a benign and infinitely skilled performance, and one that belongs absolutely to this particular and fairly absurd moment in the history of nations. Society gets the art it deserves. Almost certainly, this particular work says more about us than it does about its elusive but eminently sane creator.

—Calvin Tomkins

MURAL WITH BLUE BRUSHSTROKE

To make *Mural with Blue Brushstroke*, Lichtenstein drew on sources ranging from the most exalted to the most banal. Classical architecture (2, 14) provided inspiration, as did the site itself (8, where painted windows align with real ones). Homages to twentieth-century masters abound: Léger's people (1), Kelly's color fields (6), Matisse's split philodendron form (9), Arp's silhouettes (10, echoed in a piece of Swiss cheese), De Kooning's brushstrokes (12), Stella's triangles and French curves (15), Johns's flagstones (16), and Braque's balusters (20). Art styles—like Abstract Expressionism (11, 12, and 13, the latter with its "perfect painting"), Cubism (20), and Art Deco (21)—and artist's tools (4, 5, and 15) appear. And bustling around amid all this high culture are images of everyday modern life, those perennial sources of fascination to Lichtenstein: sunbursts (3), copy books (17), advertisements (7), food and drink (10, 18), and, of course, comic strips (19).

1. Detail of *The Dance* by Fernand Léger

2. Facade, Library of Celsus, Ephesus

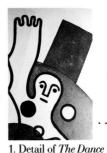

7. Ad for Elgin watches, 1950s

8. Detail of the mural in place at Equitable

9. Henri Matisse, *Music*, 1939

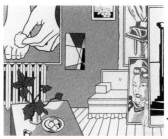

13. Roy Lichtenstein, *Artist's Studio —Foot Medication*, 1974

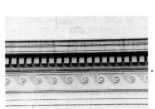

14. Entablature on downtown New York building

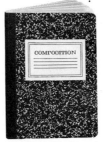

17. Classic black-and-white composition book

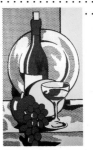

18. Roy Lichtenstein, *Still Life with Red Wine*, 1972

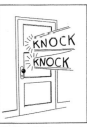

19. Roy Lichtenstein, *Knock Knock*, 1961

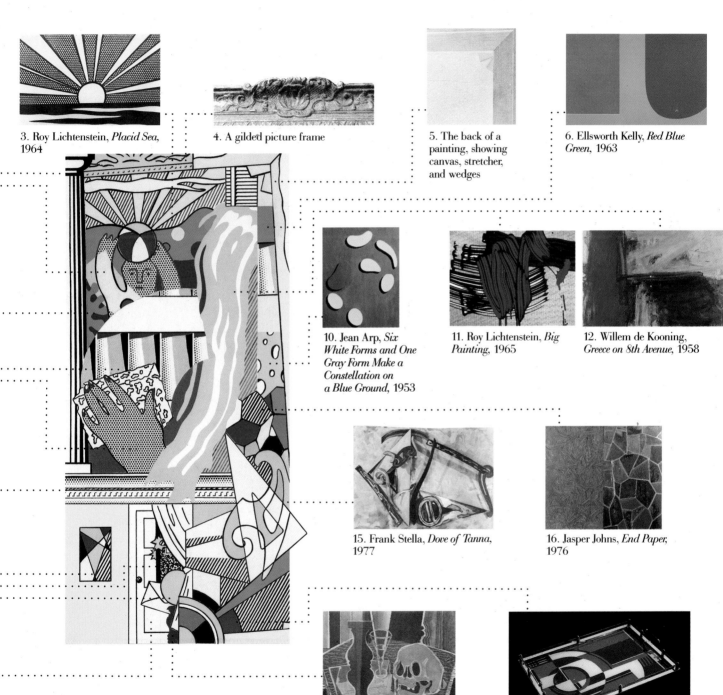

3. Roy Lichtenstein, *Placid Sea*, 1964

4. A gilded picture frame

5. The back of a painting, showing canvas, stretcher, and wedges

6. Ellsworth Kelly, *Red Blue Green*, 1963

10. Jean Arp, *Six White Forms and One Gray Form Make a Constellation on a Blue Ground*, 1953

11. Roy Lichtenstein, *Big Painting*, 1965

12. Willem de Kooning, *Greece on 8th Avenue*, 1958

15. Frank Stella, *Dove of Tanna*, 1977

16. Jasper Johns, *End Paper*, 1976

20. Georges Braque, *The Baluster*, 1938

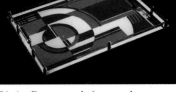

21. Art Deco tray, designer and manufacturer unknown

31

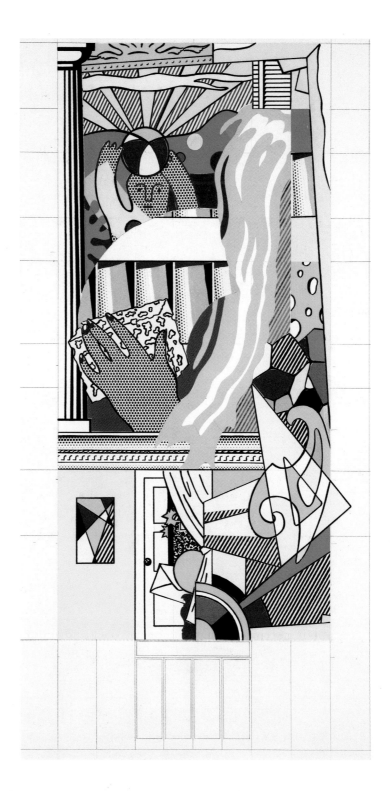

32

A SINGULAR COLLABORATION

In the summer of 1985, the photographer Bob Adelman came to The Equitable to propose his idea for documenting the production of Roy Lichtenstein's commissioned work, MURAL WITH BLUE BRUSHSTROKE. Although Roy was not scheduled to begin the execution of the painting until the late fall, Adelman had already spent countless hours tracking every phase of the painting's design. We were astonished by the photographer's relentless and dogged pursuit of his subject. He talked of eventually putting the material together in book form, but it was clear that the real inspiration for his efforts came from his desire to put the making of the mural on record. What resulted is an engrossing archive on the creative process during the execution of a monumental painting by one of the most important artists of our time.

Beginning in the fall of 1984, Lichtenstein labored on the thinking phase of the production, the design for the maquette. Using cutouts of colored paper, he ordered and reordered the configuration of the design to create a consistent and whole work. Adelman captured the evolution of the work and provided an invaluable record of the decisions, accepted and rejected, that Lichtenstein made.

Lichtenstein presented the maquette for Equitable's approval in November 1984. The maquette consisted of a patchwork collage of painted papers, silkscreened dots, and pencil lines. With an image size measuring 34¼ × 17½″, the maquette was a tightly packed conglomeration of ideas referring to the artist himself, to his peers, and to the phenomenon of painting on an inflated scale. The maquette was ambitious in its arch simplicity, fascinating for its straightforward allusions and visual puns.

Opposite:
Final study (maquette) for MURAL WITH BLUE BRUSHSTROKE, 1985. Cut-and-pasted printed and painted paper, India ink, and pencil, on ragboard, 34¼ × 17½″

Opposite:
Fixed scaffolding in front of
mural in process

The presentation and acceptance of the maquette were followed by a hiatus of several months during which time the building was constructed. There were meetings with the artist, engineers, and conservators to determine how the surface would be prepared. The mural was to be acrylic on canvas applied with a natural adhesive to a plaster wall, constructed on a honeycomb bed to compensate for the shifts of the building structure and to prevent cracking the mural surface. The entire plane was to be attached to a limestone wall. During this interim phase, Lichtenstein performed his own artistic calisthenics to prepare for the execution of the painting: experimenting with the change in paint viscosity, calculating the quantities of the premixed colors to be used, trying the readability of various sizes of Benday dots.

The execution of the work took approximately six weeks. Beginning in November 1985 and extending into the first week of the new year, the artist and his assistants worked methodically to complete the picture. First, a slide of the maquette was projected on the wall, the outlines loosely sketched in with black tape. Second, the crew moved up and down the face of the mural on a multistoried scaffolding separated by stairs. Although the intellectual process was behind him, the sheer effort involved in moving the image to the enormous dimensions required a rigorous, sustained energy.

Anyone who has seen Lichtenstein knows him to be nimble and energetic. By contrast, Adelman is a man of large carriage with enormous hands, yet he delicately followed Lichtenstein through every turn, often scaling freestanding scaffolding more than fifty feet high so as not to miss a single shot. We are grateful for his perseverance—and for Lichtenstein's unending patience—that we may now benefit from this enlightening record of the work.

—Pari Stave
Curator, The Equitable

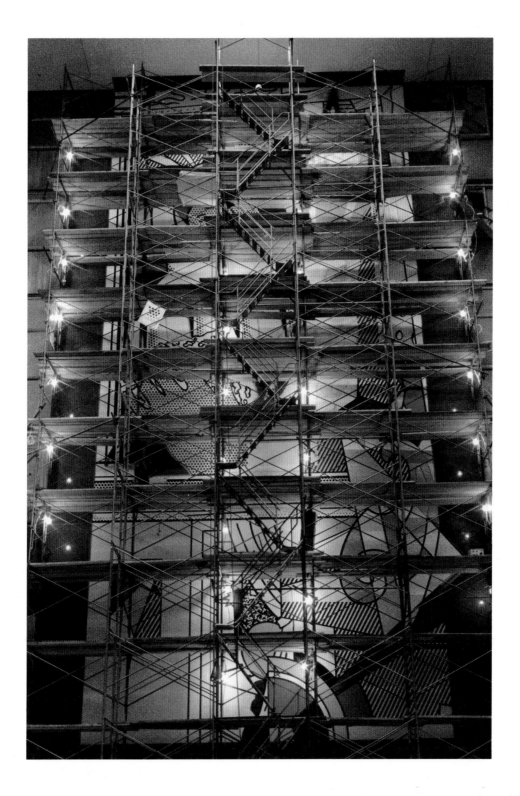

Art is long, life is short. Roy Lichtenstein was puncturing that piety when I first got to know him, just before Christmas 1983. He was painting a mural directly on the nearly 100-foot-long wall of Leo Castelli's Greene Street Gallery. After many months of preparation, Lichtenstein and his crew painted the mural in a remarkable two weeks. It would be on view for a month and then literally disappear, covered over. Why? What was the artist's motive?

Roy has a sunny disposition. He works in a very orderly and deliberate way, purposeful but unhurried. That the painting of the mural hummed along ahead of schedule was typical for him. He was unfazed by my leaning over his shoulder with my cameras and, when he stopped, would cheerfully answer my questions. Bemused, he suffered my attempts at humor. After he pulled off a piece of tape from the wall, or something else equally trivial, I might wonder aloud, "What is the art in art?"

Toward the finish of the GREENE STREET MURAL, I had a chance to talk to him to try to understand why he was making this temporal mural. Did it have anything to do with his rejection of the crassness and commercialism of contemporary art that conceptualists criticize? The current art world, the argument goes, puts artists in the position of being producers of consumer products for the marketplace. Or was he under the spell of the belief of some so-called primitives that the expressive masks used in religious ceremonies have magic powers only temporarily and then are useless? For some time he'd had his eye on this big wall, he told me. In part, his work was about enlarging images. Working this big seemed like the ultimate magnification. He regretted that the mural couldn't be preserved (except in photographs, see page 28), but he found pleasure in the absurdity of making something so big that was going to disappear. To my persistent *why*'s, he finally looked at the wall and said he made it "for the pleasure of the dance."

One of my primary impulses as a photographer is to document a process—by looking hard and long at an activity, to search out images that clarify and define it. The GREENE STREET MURAL experience had intrigued me, but I wanted to understand and follow completely Roy Lichtenstein's way of working and thinking. I began spending time with him, photographing and talking, looking at his work, and reading about him.

My reflections led me to a perspective. When Roy Lichtenstein first assaulted an art world dominated by Abstract Expressionism with his comic-strip imagery, his work was viewed as a scandalous bad joke, or a reactionary return to realism, or a Dadaist incursion of mass culture into the sacred precincts of high art. What was not foreseen, of course, was that a consummate stylist who would affirm and extend the modern vision was making his debut. By isolating, enlarging, and subtly transforming comic-strip frames in his canvases, Lichtenstein asserted the visual vitality of this very American form of vernacular expression. From his paintings, we learned that the flat primary colors, Benday dots, and black outlines of vulgar cartoons anticipated the Cubist principles of the School of Paris. As Lichtenstein's work evolved, he appropriated art from sources as diverse as the Parthenon and the pyramids, the School of Paris and Expressionism. Using his refinements of comic-strip technique, he subtly transformed our art tradition and made it his own.

In 1985 Roy was awarded the Equitable Building mural commission. He hesitantly agreed to let me follow him around and record the entire creation of the mural. Work began in his studio, a large, bright loft surrounded on three sides by windows. For an artist's work space, it's a very tidy place, open and quite practical. The order seems less a matter of compulsiveness than an effort to facilitate his prodigious output.

Usually Roy would be alone in the morning. He would work intensely for fifteen

Making notations on building plan

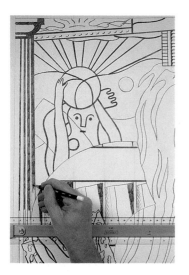

Above:
Drawing column

Opposite:
Referring to photograph of
mural site

minutes to a half hour, then step back to evaluate. At times the back-and-forth might be more frequent. About noon his assistants James de Pasquale and Rob McKeever would arrive. He might instruct them to finish something he began, or answer questions. Artistic decisions were made by Roy; his assistants implemented them. The atmosphere was serious, relaxed. Classical music often played in the background. A man totally engrossed, delighting in what he does.

While working out the mural maquette, Roy was simultaneously painting a series of Expressionist landscapes, working on metal and wooden brushstroke sculptures, designing a banner, and creating a series of landscape prints.

The work on the maquette took six weeks, on and off, and began with a good deal of eyeballing by Lichtenstein of the building plan. Lichtenstein had the "cliché" notion of relating some of the elements of the mural to the building site. Of course, anything clichéd is for him a goad to mischief. Early on he worked out a sense of top and bottom, a sun near the skylight and a wooden door above the metal auditorium doors. The first architectural images he worked with were a Doric column from his Temple of Apollo paintings and entablatures from his series of the same name. When I asked him about his choice of classical architectural references in a modern building, he admitted they were "out of place in this place." So much for clichés.

The photographs are candid. The comments are from conversations with the artist when he stepped back. What follows is a record of the prodigious and careful effort, the techniques and ideas, of a modern master at the top of his form.

—Bob Adelman

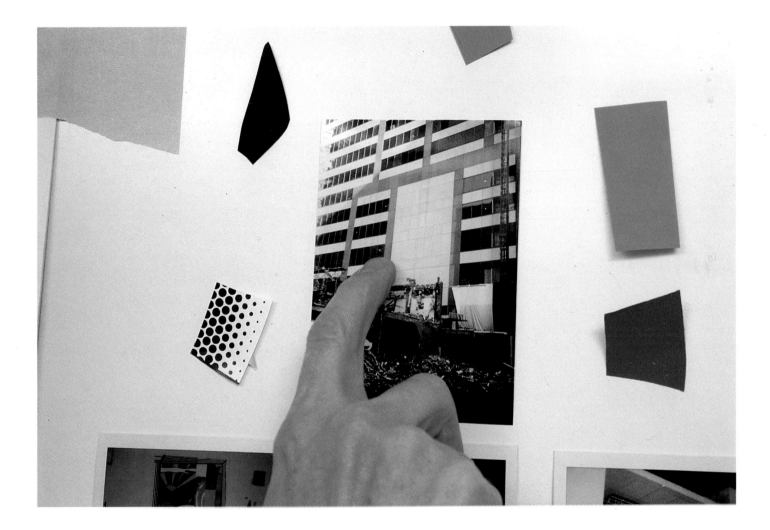

IN THE STUDIO

The art consultants at Equitable had seen the GREENE STREET MURAL and wanted a big picture for themselves. When everyone agreed to go forward, only the dimensions—sixty-eight feet high by thirty-two feet wide—were fixed.

Quite naturally, one of Lichtenstein's major considerations was the nature of a mural. "A mural has a kind of architectural structure. It's different from a painting. Also, there are more elements here than you'd have in a painting. It looks as though it's telling a story even though it isn't. I don't mean that it isn't saying anything. References to Matisse, Léger, Jasper Johns interplay to have a certain meaning. What it is is hard to say.

"This is muralesque and it consciously relates to the architecture. The other mural in the building, the Benton, is saying something. Benton has a definite social point of view. I have an ambivalent point of view, which I'm getting across. I can't make out the world and it shows."

Roy first drew a grid of the building and the stones and windows, to see how the actual architecture of the building might be integrated in the mural. "I thought there might be something silly about using the same modules of the architecture in the painting. To take the architecture into account is a cornball idea, but it's absurd to be doing a mural in the first place. It's absurd to have a door over a door, and it's absurd to put a big cartoon in their building. But the motivation is to make it as silly as possible anyway."

Roy finds it difficult to define the concept of content. "It's what a picture gives off. You can explain an opera by telling the story, but what's the music? The music is the opera. The libretto is usually ridiculous anyway. It doesn't really make any difference. Without the music, what would the libretto be? Nothing. In most cases, it would be bad writing. What's interesting is the music."

Roy started with an element. Here he thought about the frame and the column and the entablature. Then ideas flowed. Roy likes to use subjects like the Temple of Apollo and Greek ruins, where the emotion that is attached to the subject is disproportionate to the nature of his drawing. Mostly he picks elements because he believes they will work with other subjects in terms of size, position, brightness, and also absurdity. "I don't particularly care what the subject is, but it might as well be amusing. I always like to toy with architecture."

The Léger Figure

Monograph with illustration of Léger's The Dance

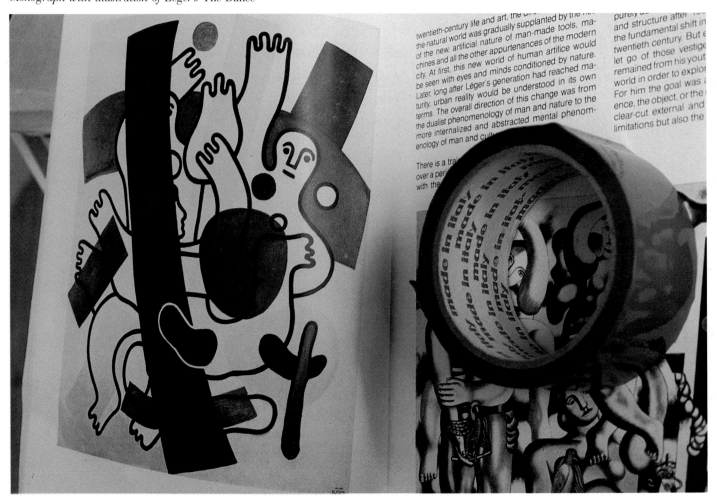

To appropriate, Lichtenstein finds elements in the general vocabulary that go with his way of working. He restates other artists in his own terms, which is not so different from the way Van Gogh "did" Rembrandt or Picasso "did" Velázquez.

"All painters take a personal attitude toward painting. What makes each object in the work is that it is organized by the artist's vision. The style and also the content are different from anyone else's. They are unified by the point of view—mine. This is the big tradition of art."

Detail from The Dance

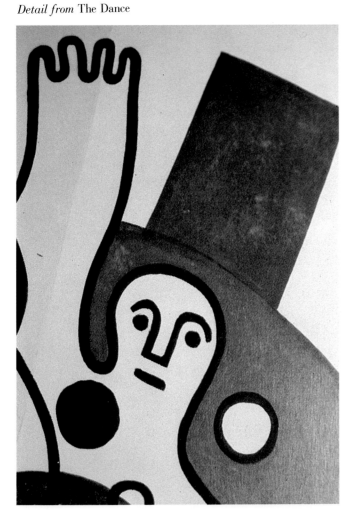

Lichtenstein's Girl with Ball *beside traced detail of* The Dance

Roy's idea is to do inappropriate subject matter, like commercial images or works of other artists. "I'm not making a judgment as to whether or not I like cartoons or whether I'm putting down Picasso, for instance. I'm changing Picasso into a cartoon and making my own painting, which is also what I did with comic strips. Mostly I use things that come with baggage—like pyramids or Cézanne or brushstrokes. When I get finished with them, instead of being rich with association and history, the pyramids, for instance, are a couple of triangles on a piece of paper. That's supposed to sum up their incredible legacy of associations."

Traced Léger

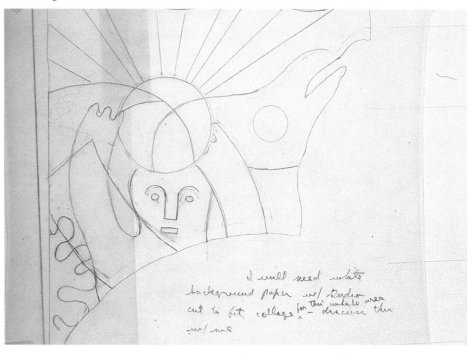

I will need white background paper w/ Studio cut to fit. collage for this whole area — discuss this w/ me

Penciling the tracing paper for transfer to the maquette

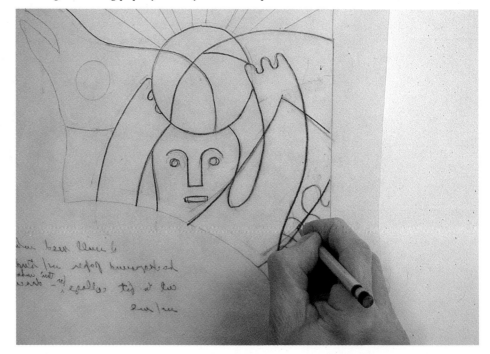

44

One of the first elements Roy tried was the Picasso woman with a flowered hat, but he later decided that the Léger would lead some-where: the beach ball turned into the sun. Roy likes the Léger because it looks odd. "To have a Léger hold a beach ball looks funny to me."

Cleaning up the transferred tracing

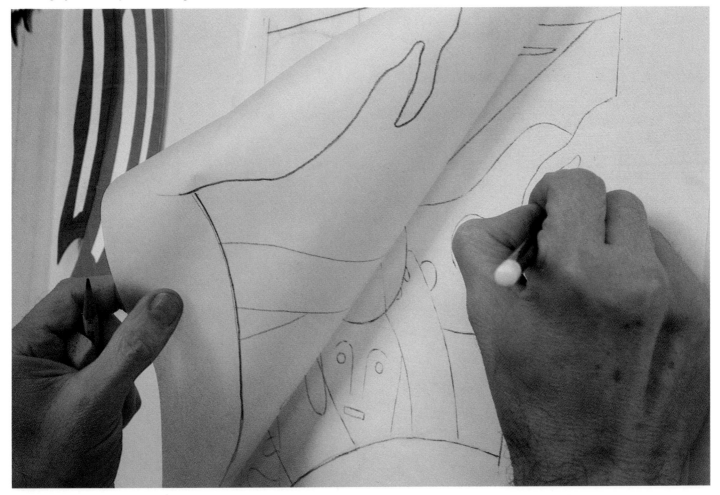

Lichtenstein transfers subjects by tracing them by a tried and true technique: he pencils over the back of the tracing and then retraces the lines to transfer them. "I'm taking over the Léger figure. I'll use red dots for the flesh tone. I always do."

Roy did not fall in love with the Léger image. He found it usable because his work had certain Léger aspects—he too uses industrial subjects and black lines. "This Léger has taken on the look of graffiti."

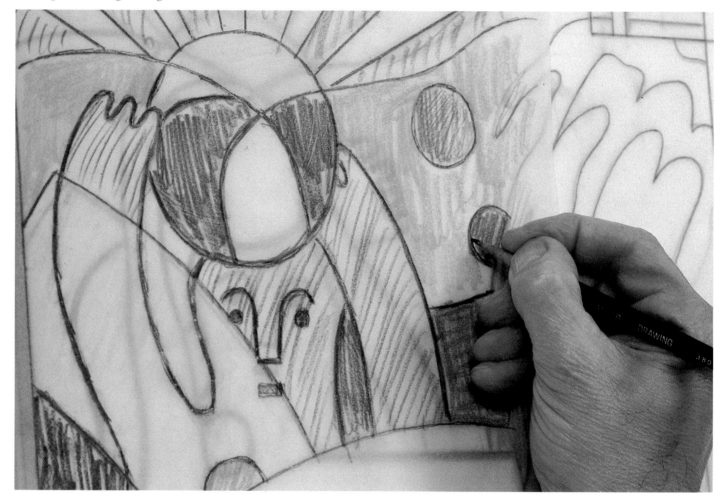

Lichtenstein is emotional about drawing. Drawing, for him, is the placement of marks—intuiting where each one will be set and, at the same time, keeping in mind the whole work. The mark has to be in the right place to strengthen the visual field. "For the mark to be in the right place," says Roy, "is like choosing the right note to follow a group of notes in music, assessing how much value the note will have and what its pitch is. You don't see those considerations in painting because its final form does not involve time. In art, you have position and contrast rather than pitch and time."

Drawing and coloring the Léger

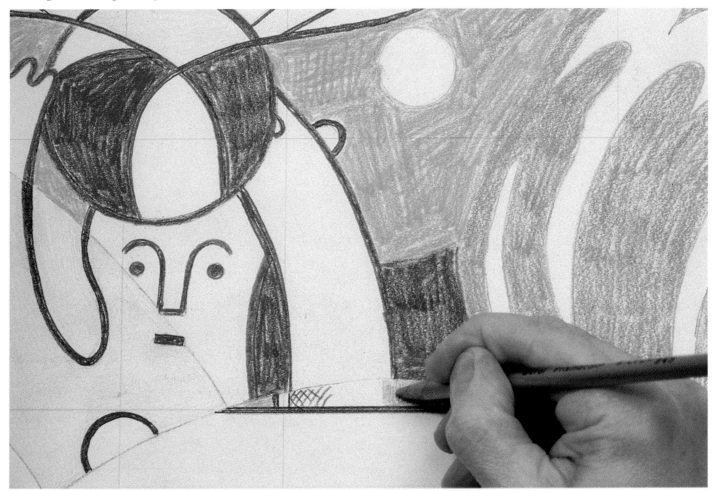

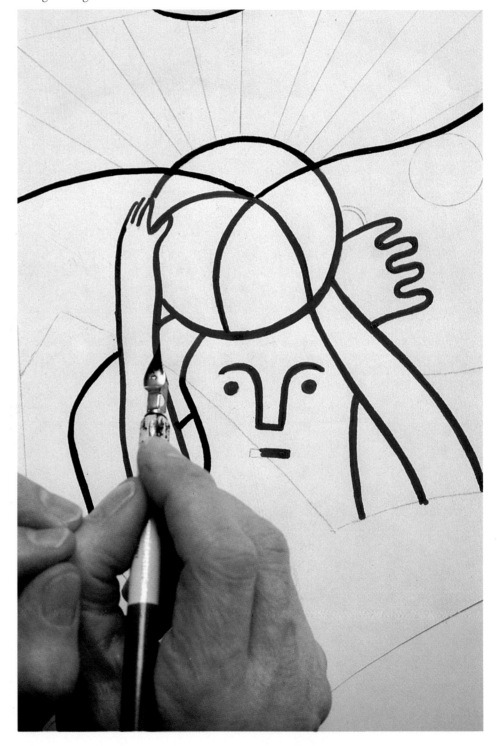

Outlining makes the work more immediate, and the outline acts as a color in itself.

Roy suggests that the sun and rays at the top of the mural are spiritual, but says, "That's about as religious as I get!"

Roy thought in the beginning of making all sorts of skies at the top, water for the middle, and grounds for the bottom. Then the mural would be a large landscape. But after doing the "up" elements, he did not continue the theme with subterranean references in the lower part.

48

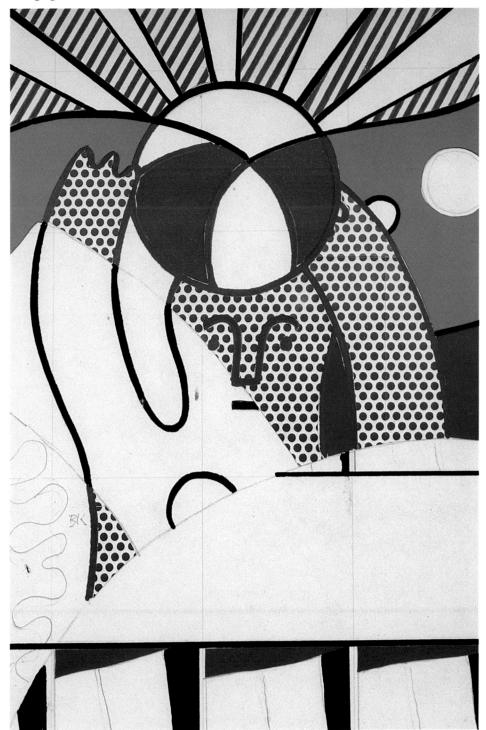

The beach ball is a center of interest partly because it has a great deal of contrast. Ordinarily a viewer would look to the center of the picture, where the sponge is in this case, but because that area is not particularly contrasty, the eye goes instead to the beach ball/sun.

Roy thinks that the Léger will be very vibrant when it is finished. "I'll have yellow and green next to the red dots. It's a wild combination."

In contrast to color areas with less obvious subject matter, people will invest the face, as unrealistic as it is, with life. "People realize that that face isn't real, but they'll talk about it as though it were. I think of this animism, and I like to play with the unreality of the object and people's investment in it."

49

Gluing collage element

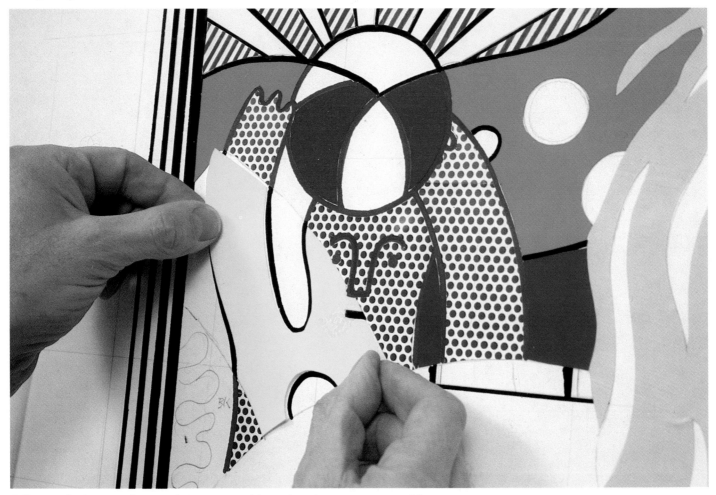

Collage is Lichtenstein's way of visualizing how the finished painting will look. "I can change things constantly and get shape and color at the same time. On the very large scale of the mural, a projection of anything other than a cutout would be fuzzy and the colors would be wrong. A collage tells me more exactly what the painting is going to be."

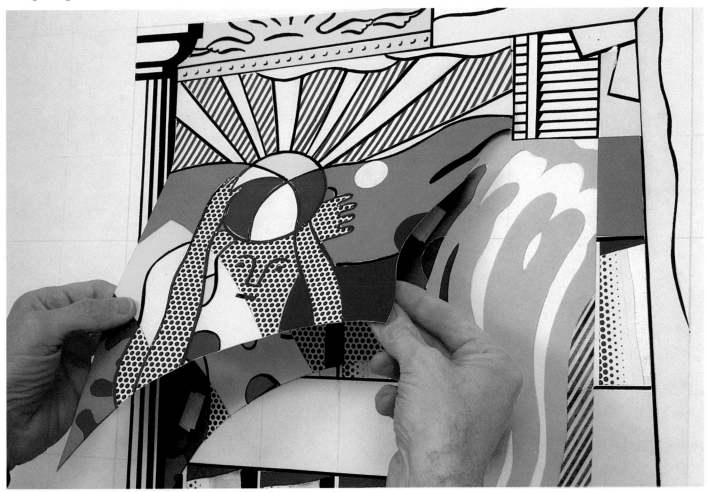

At the very top is a picture frame next to a stretcher frame. The stretcher frame goes around the picture, and you can see a bit of it at the bottom. "The frame is like quotation marks on the mural."

What a painting means probably makes a difference, because the artist probably meant something, but trying to understand what the artist meant begs the question of the significance of the work. "All art, good or bad, has meaning. But

what do the meanings mean? In music like Bach or Mozart, the notes or phrases have no particular meaning. In romantic music, of course, the notes could connote waterfalls or storms."

Rejected Elements

Rejected tracing of Girl with Ball

Rejected collage of Girl with Ball

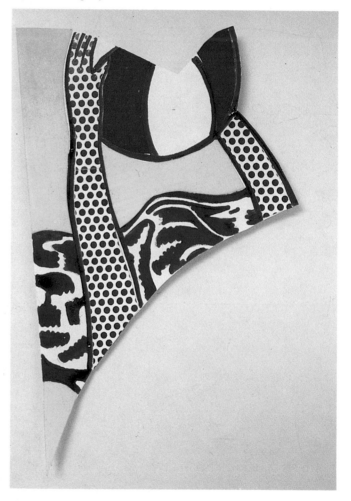

Rejected colored tracing of Picasso girl with flowered hat

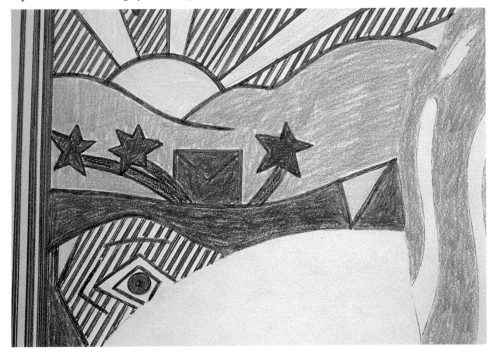

Rejected collage of Picasso girl with flowered hat

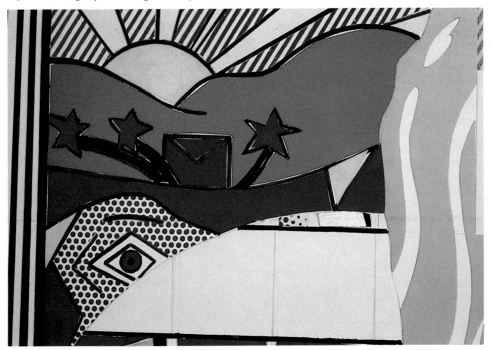

First Roy had a Picasso girl with flowered hat. It gave him something to think about. "I reject a hundred images to every one I pick. There must be a reason for my doing that. Sometimes an element looks too much like other elements. Sometimes it contrasts in a certain way. I start. One thing leads to another.

"For an element to stay, it has to be the right note. The Picasso eye is gone now." The Léger worked better.

53

The Ellsworth Kelly Area

Alternatives for Kelly area

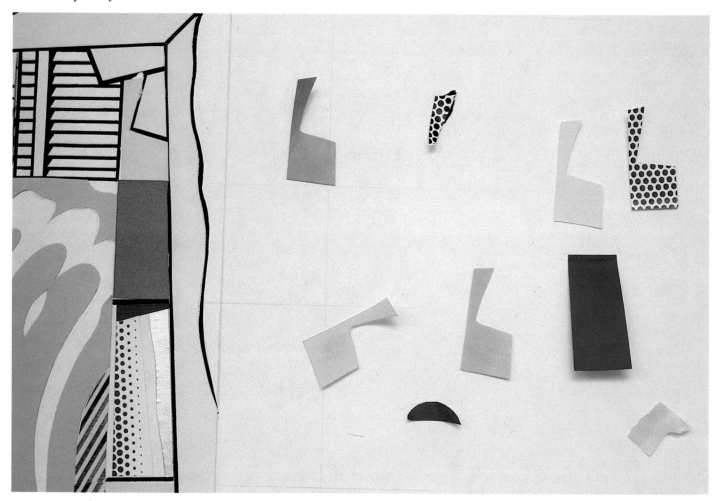

In the mural, the Kelly area started off lining up with the window and the architectural detail, but it didn't come out looking like a Kelly. The little blocks of color could be Serra as well.

"I may change some of those colors on the upper right-hand side. It's the only part I'm really concerned with right now."

Roy uses black and white in the venetian blinds. He had thought of having a lot of black and white and silver things, not colors. But the silver didn't work very well.

As a rule, Roy doesn't modulate his areas of color; he gets an effect of more immediacy. Modulation is seen by him as atmosphere, and atmosphere stands for distance.

Affixing parts of Kelly area

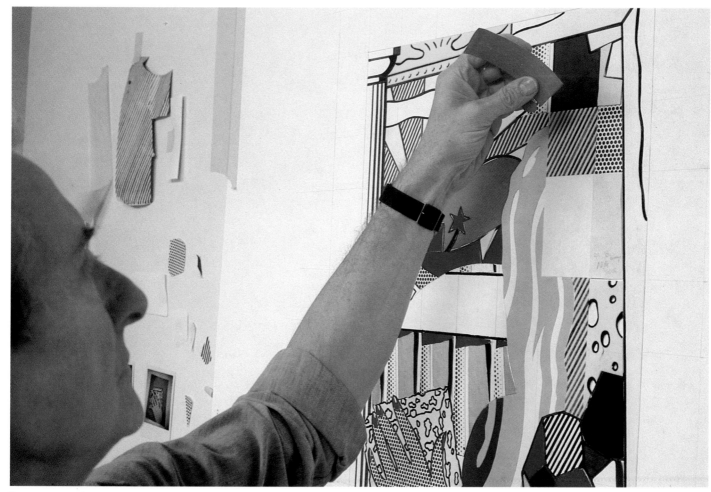

Roy treats color quantitatively,
which had its clearest beginning
with Cézanne and Van Gogh.
He tries to make tonality out of the
sizes and intensities of color areas.
"I want you to feel levels of brightness,"
he says, "that the yellow can't be
yellower, the blue can't be less blue."

56

The Impressionists of course were
concerned with a sense of air as well
as a sense of light. Lichtenstein
is concerned with the fact that art is
not only flat, which is obvious, but
that it is sensed as flat.

Affixing parts of the collage

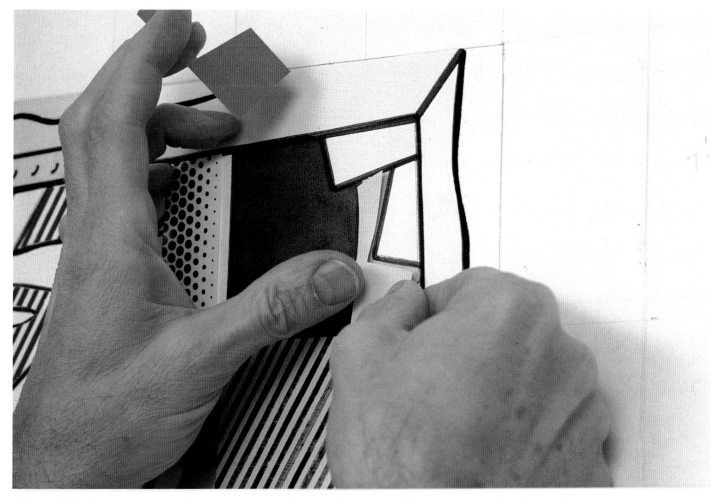

All art is flat, because it is on the surface. "I also feel that it should be sensed as flat. I like to preserve the feeling of the 'work surface.' This doesn't mean that observers won't project space into the picture. There are a number of clues to signify space and depth. If you don't modulate color and keep outlining things with black lines, you have fewer clues for spatial depth. I do it purposely because it's more immediate and it seems to be the *thing* rather than a *picture of the thing*."

The Brushstroke

"This is going to be the world's biggest brushstroke. It's tying the painting together. Anyway, it might give that impression."

All paintings are made of brushstrokes. In the spirit of Pop, Roy focused on some of the bravura excesses to which it was put. He then made plain and unfancy brushstrokes. "I'm getting more fancy, I realize, but I try to keep it straight!"

He uses brushstrokes to examine painting the same way the dots examine printing. Of course, the brushstrokes are entirely artificial. They don't even look like brushstrokes. "I just call them brushstrokes and they can be seen as brushstrokes—the cartoon ones."

58

Details of cutout

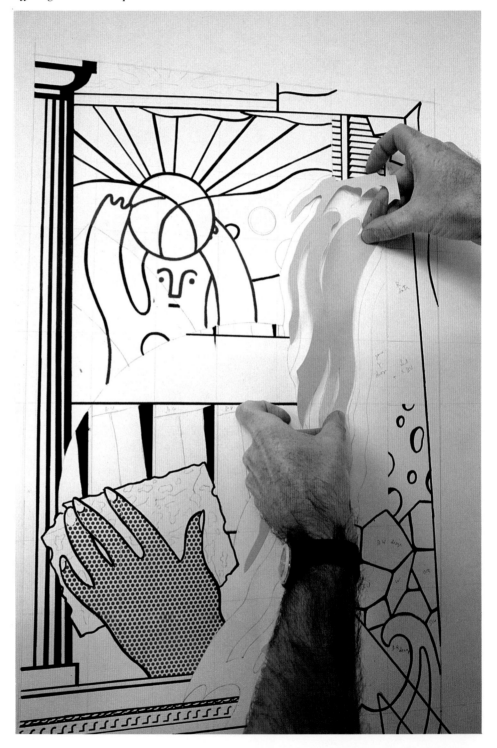

60

The Benday dots are artifice too: they're visible, whereas in printing, you can see them only if you look closely. Today in advertising dots are sometimes used in a Pop style and are intentionally visible.

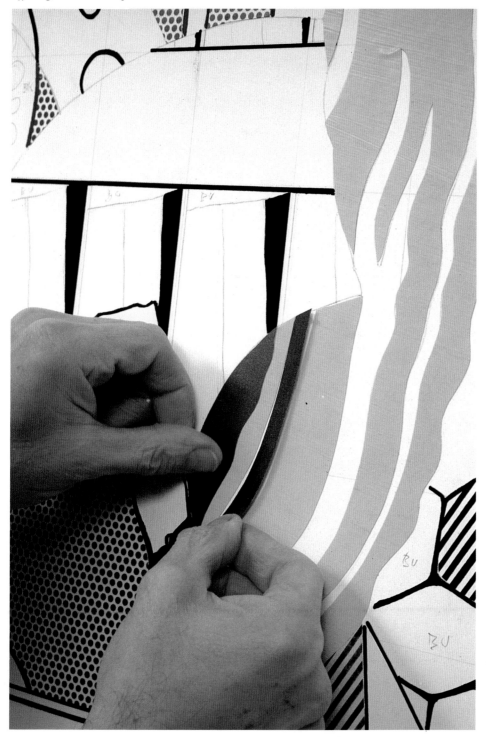

Roy selected this particular blue for the brushstroke because it furthered the tonality of the painting—the overall sense of color it has. "You start with a color and then add to it to make it more vital. Here in this section, I started with blue—the blue on the brushstroke—and then I put in the yellow and green stripes. They struck me as unusual colors together. Just went on from there . . ."

Once the work has tonality you can build on it, like a musician composing in a particular key.

61

The Swiss Cheese

Cutting out Swiss cheese

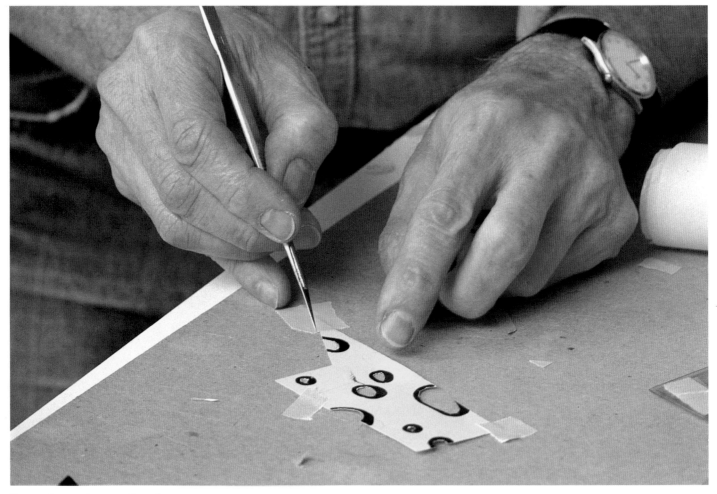

Swiss cheese the way Roy does it is
stupid-looking, amusing. The cheese
has an Arplike quality to Roy.

Working up Swiss cheese

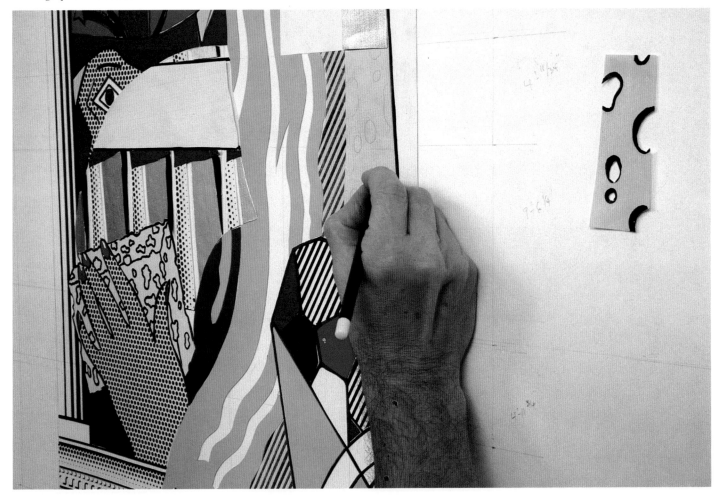

The Swiss cheese relates to the sponge in form. It also vaguely relates to the flagstones.

"I might put the Johns flagstones next to the Arp Swiss cheese, because they contrast. Actually, I'm putting all the artists into this mural, so I'm going to save the Whitney budget. They won't have to acquire anything else."

Affixing Swiss cheese element

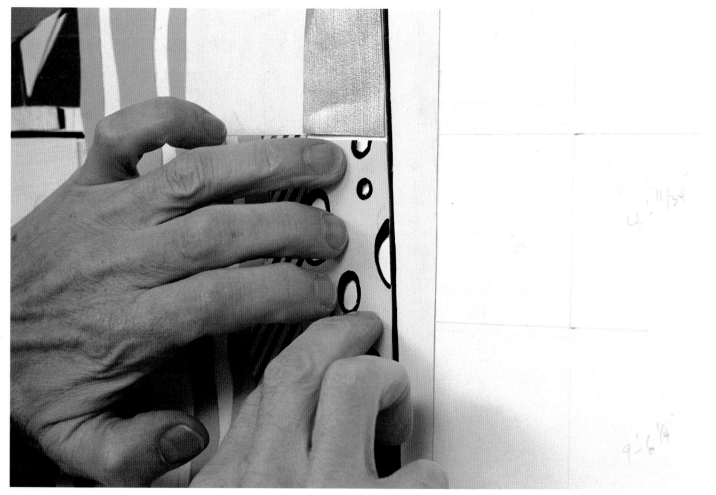

"I look for subject matter that calls for a certain color. Swiss cheese is yellow. The black-and-white holes have an effect on the color. It makes the yellow look more saturated.

"I like color that looks like nominal color. Blue sky, pink face, green trees. Stupid color."

Considering hair above cheese (ultimately rejected)

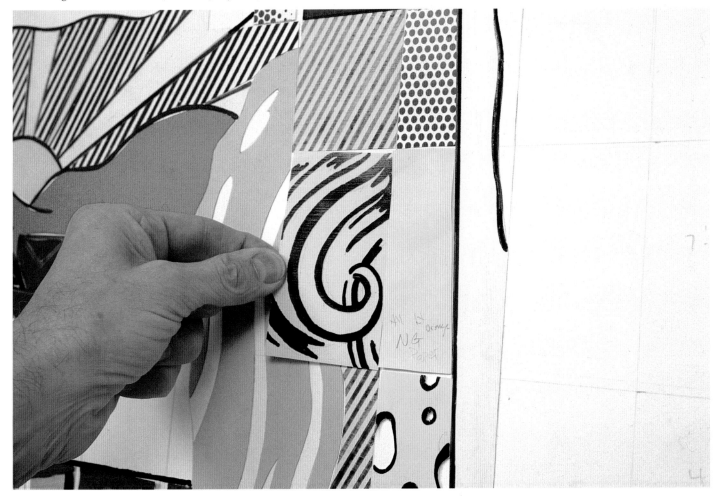

Flagstones

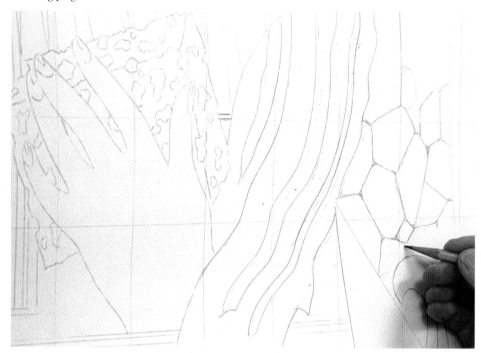

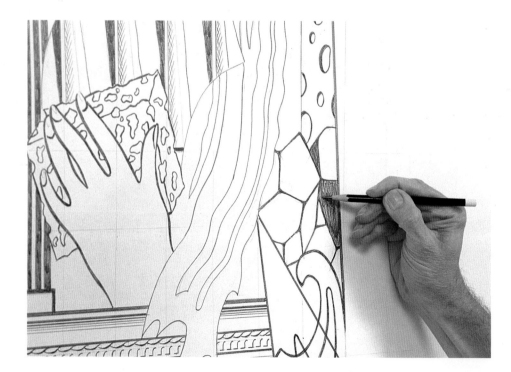

66

Coloring flagstones

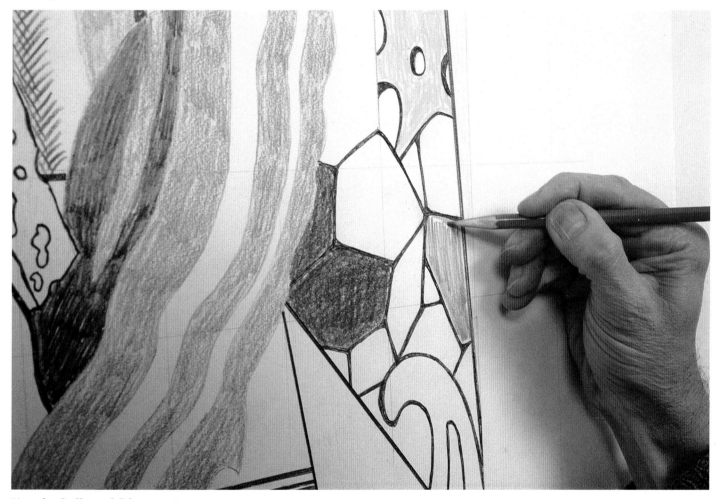

"Are the Stella and Johns ironic
references? Perhaps. It's doubtful
that they're too interested in Pop
versions of their art."

Inking flagstones

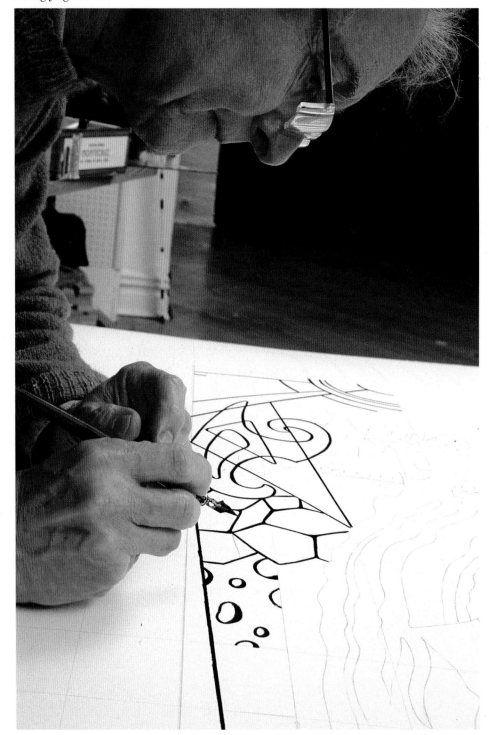

Inking flagstones

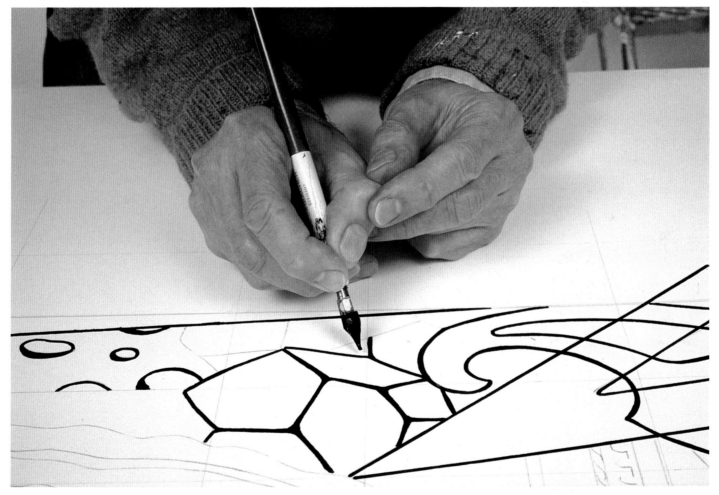

Colored flagstones

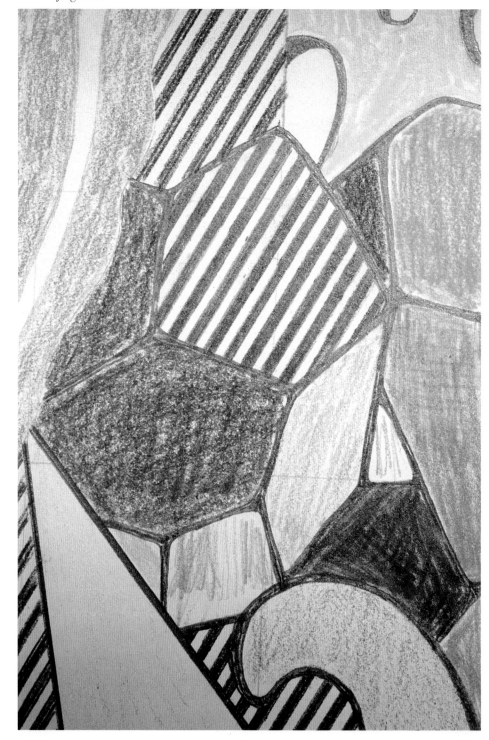

70

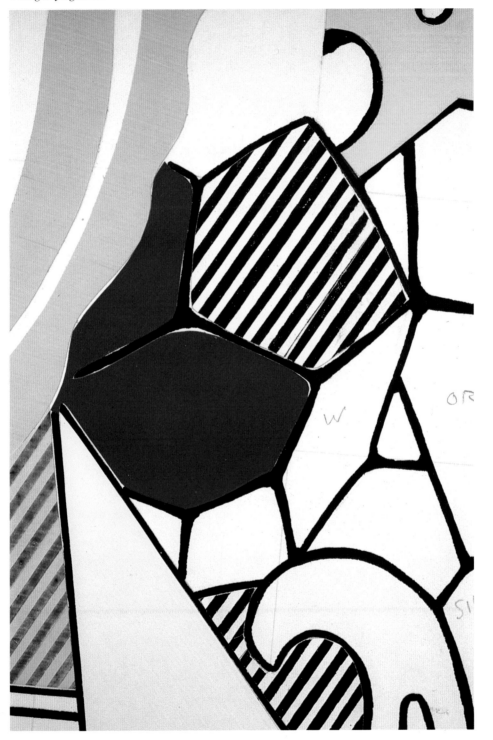

The Triangle and French Curve

Drawing triangle and curve

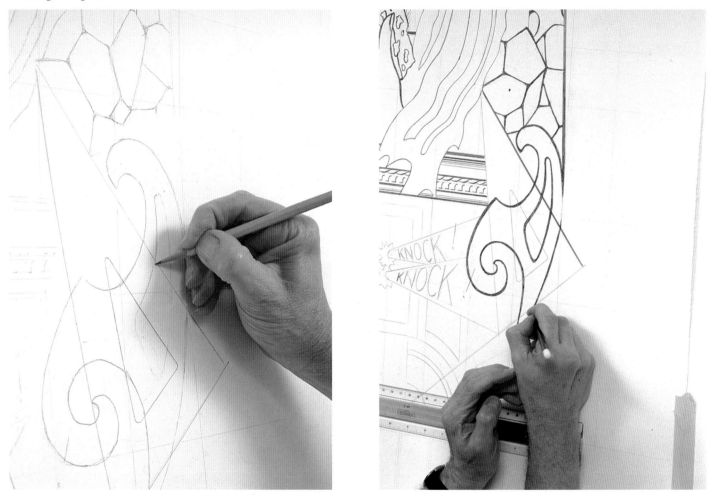

Stella probably does not use a real French curve or a real triangle. But the ones you see here remind you of Stella's. They address what is called "the tyranny of the rectangle."

Paintings have always tended to be rectangular, probably because it's easier that way. Coming out of the frame is part of what Stella's work is about. Roy's ironic comment barely pokes out of the frame.

Coloring triangle and curve

 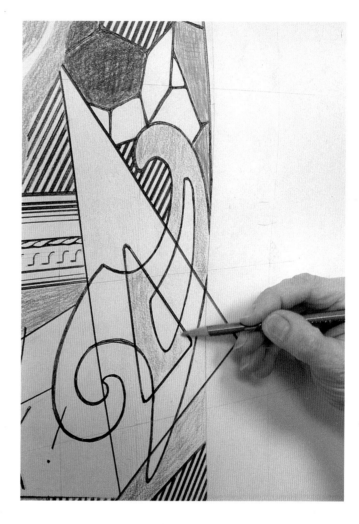

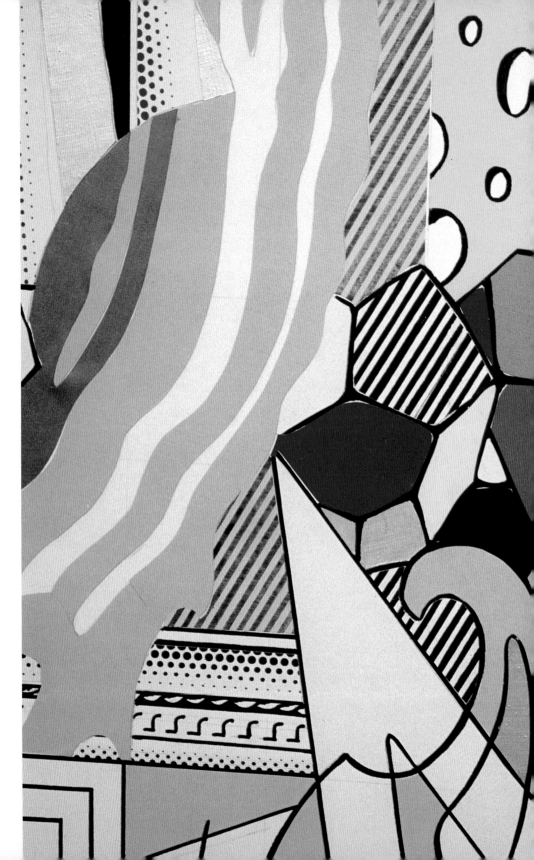

*Piece of marble from building
held up next to maquette*

74

"I rejected an earlier triangle
because it came out too far and
began to look too much like a
serious statement. I like the fact that
this outcropping looks like an acci-
dent where one little shape sticks
out of the side and makes no
contribution."

Art Deco

Drawn Art Deco area

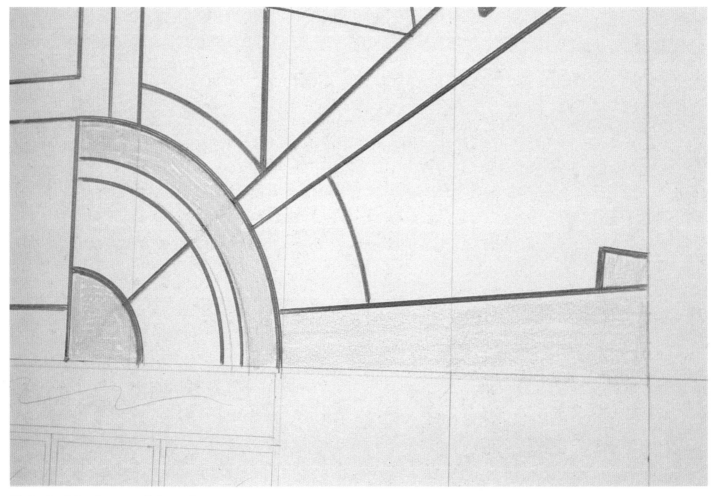

"I think of Art Deco as Cubism for
the home. It seems mathematical
and intellectual rather than visceral,
closer to my way of working."

Collaged Art Deco area

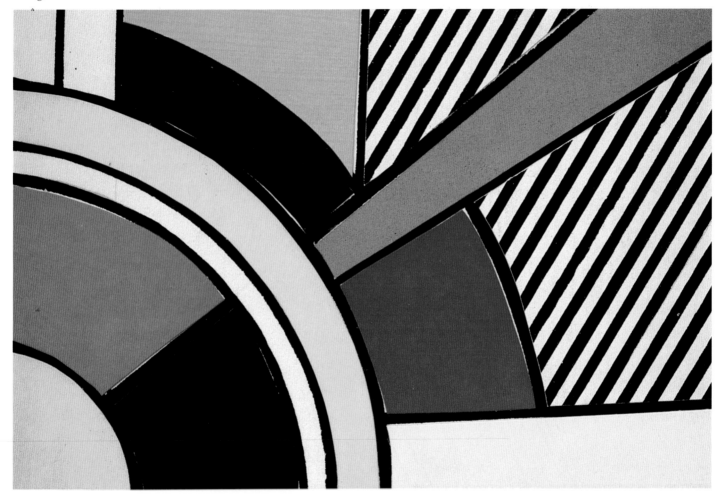

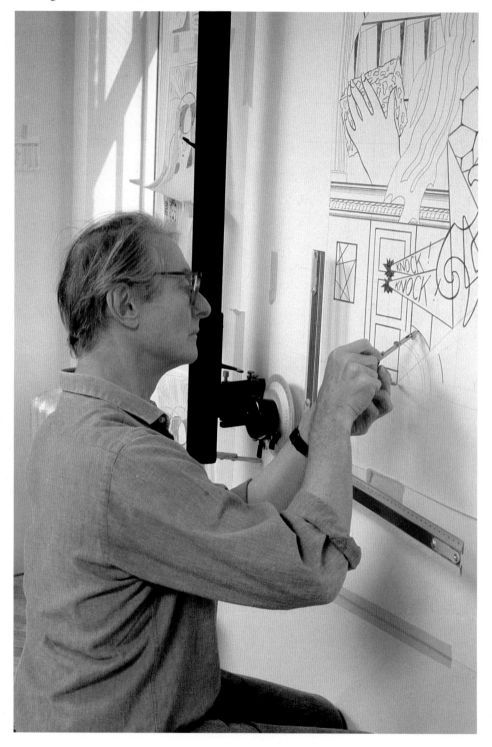

Coloring Art Deco area

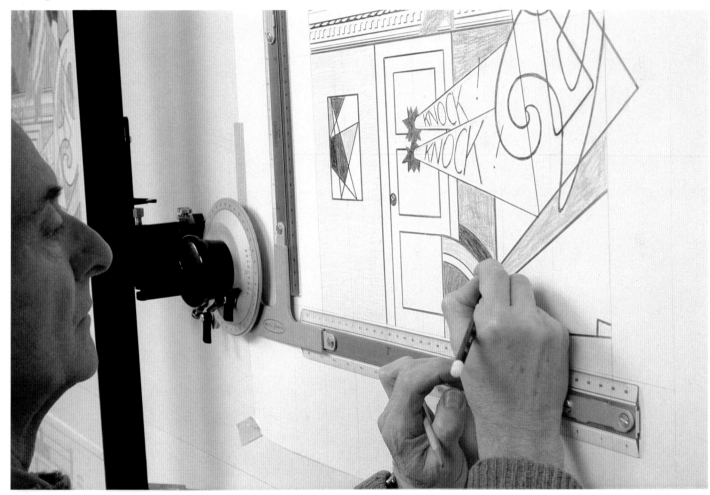

It was about 1961 that Roy got the
idea of the "audioscription" *Knock!
Knock!* with blast symbols coming
out. "It was important for me to
paint this ephemera as though it was
concrete. I did the explosions, too.
Of course, so did the cartoonists."

The "Perfect Painting"

Drawing the "Perfect Painting"

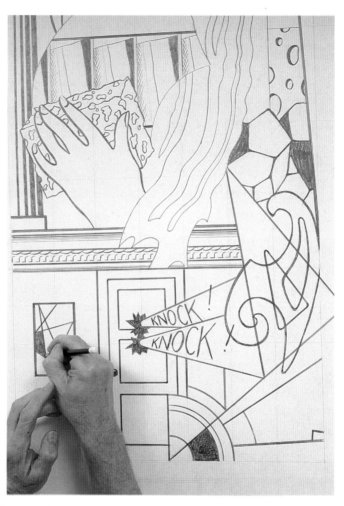

Roy refers to this little painting on the wall as a dumb painting. He has since done a series of Perfect and Imperfect paintings. They comment on a range of strategies that artists use for abstract painting. A line just goes along and hits the sides of the canvas and bounces back.

Collaged "Perfect Painting"

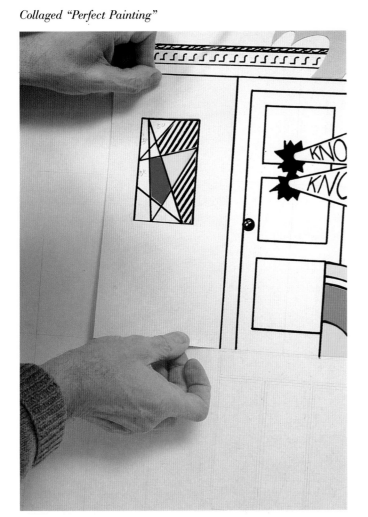

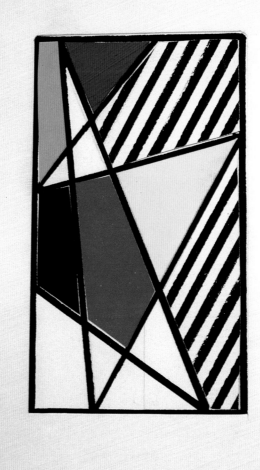

The mural seems to have several areas of color variation, contrast: the little painting, which is in the lower left, the Art Deco arch, and the beach ball area. The areas are like little separate paintings that weave together to make the composition. "I try to go as far as I can with color. It could be as subtle as possible or as screaming as possible. It's a sense you have. And it comes from positioning—which is mysterious and difficult."

The Entablature

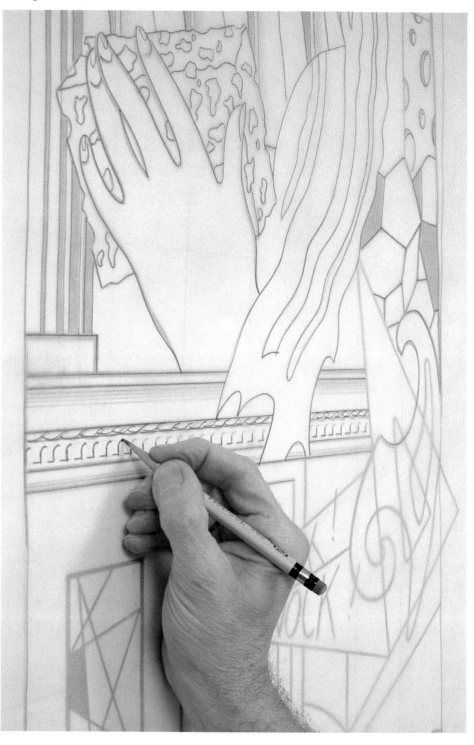

82

Roy has used the entablature before. The Entablature series was based on photographs he took in the Wall Street area. This particular version is a composite of elements in the series.

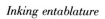

Inking entablature

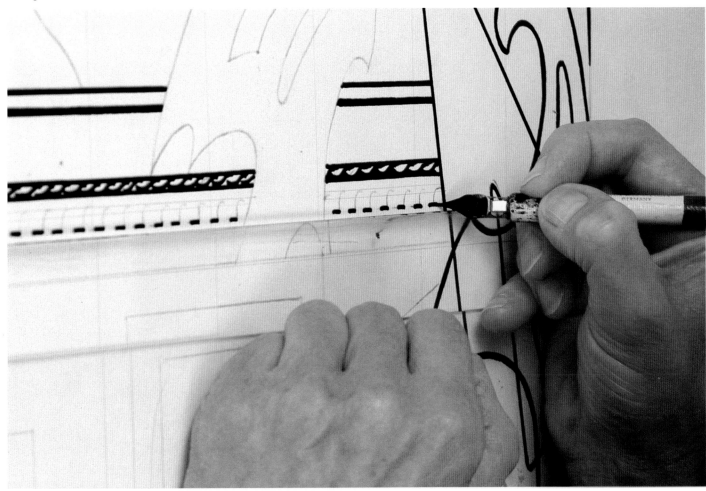

The Hand and Sponge

Traced hand

Drawing hand

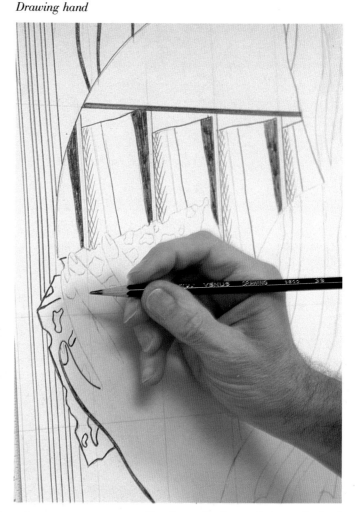

Early on, Roy did a print that was a study of hands and a takeoff on Dürer. It had four hands on it: one was a cartoon hand holding some yellow hairs; one was the Donald Duck hand with a sailor suit; one was a wooden hand with a wood texture; and one was a kind of *Guernica* hand. All together, they were a study in incongruity.

"Hands are interesting to me. Any subject in art, whether it's a still life, landscape, sunset, portrait, anything that's a genre and the work of other artists, it all interests me."

Roy kept thinking of things he had done. One was a hand with a sponge. "Well, that could be in the mural." Then he thought, "I could take off the mural with the sponge. It doesn't really make any difference. Taking off the mural would add a few more shapes to it."

Comparing hand with his own

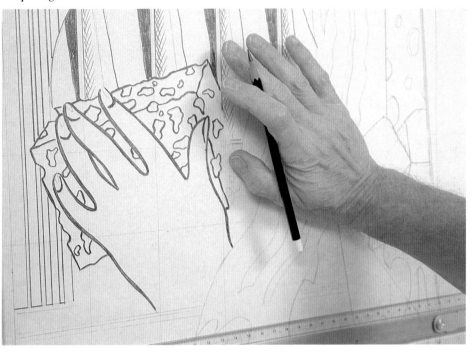

Measuring hand

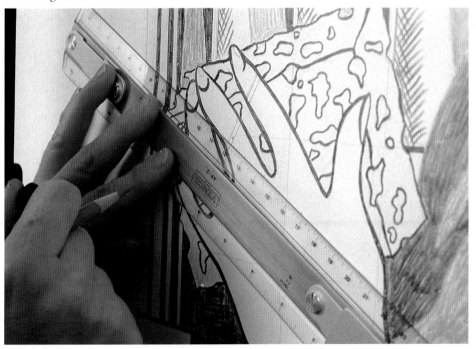

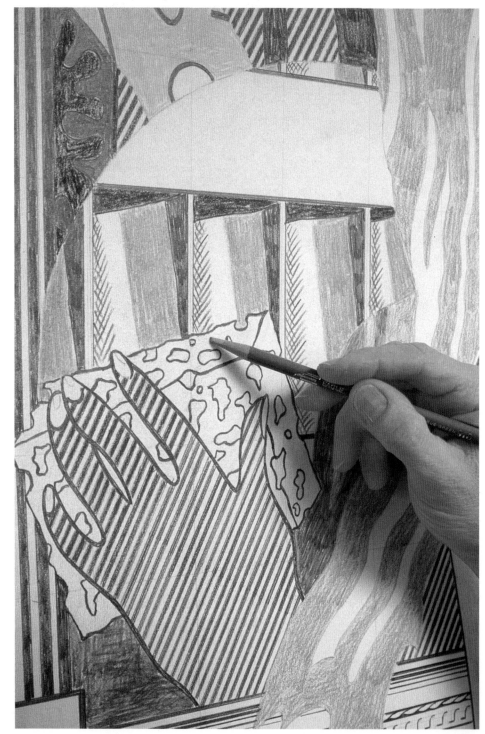

Coloring hand and sponge (stripes indicate Benday dots)

Both the sponge and the hand are highly stylized. It is the style of commercial art, which Roy likes to use because it is simple and understandable, big and contrasty. It has an apparent lack of subtlety and nuance and sensitivity. If you can make it work, it is wonderfully effective. From Roy's point of view, it symbolizes aspects of our modern world. "They have very little to do with anything real, but they will be taken for reality."

Collaged hand and sponge

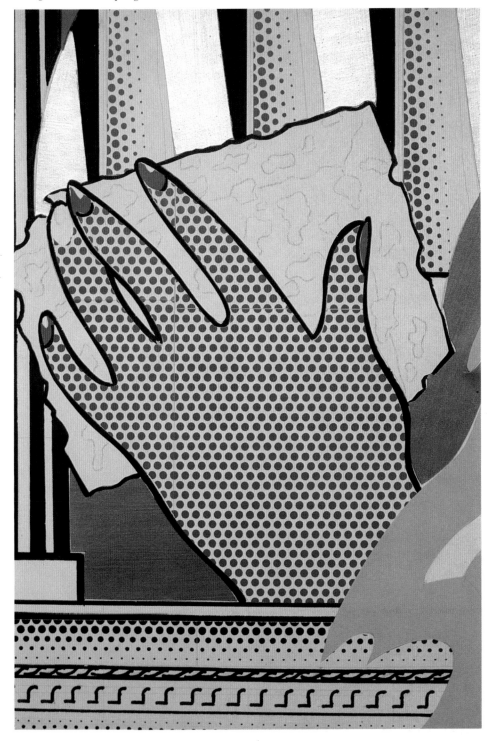

Roy has wiped out the mural to get at what is real and what is not real. Of course, the swipe is the mural and he is not wiping it out. Roy creates an illusion and then pulls it away and creates another illusion. "I show the traps you fall into when you believe the things that are painted are real: Pirandello-like."

If he wipes away the art, there is the building's window underneath. The painting serves as window dressing. Painters have always dealt with this idea: is that a fly on the painting or the painting? Is it painted or real?

87

The Split Philodendron Leaf

Leaf drawing

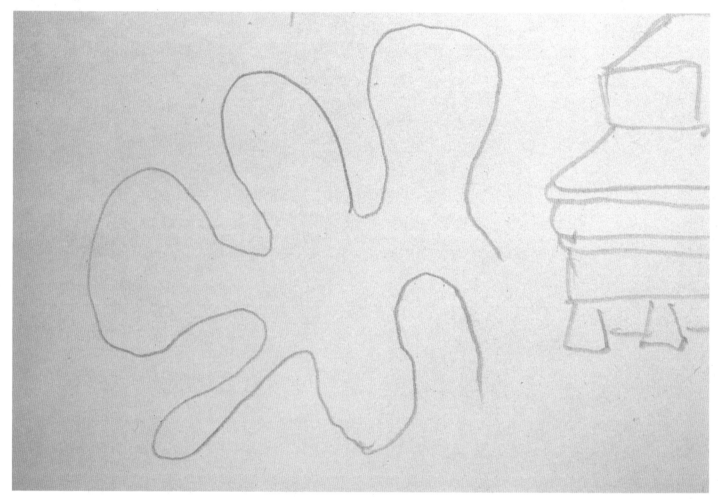

The Matisse philodendron leaf is another reference. "All my elements are plays on things I've done before—like the beach ball, the columns, the entablature. All the references are to art and architecture. BLUE BRUSH-STROKE is polyreferential: it has more levels of meaning than you can shake a stick at!"

Coloring leaf

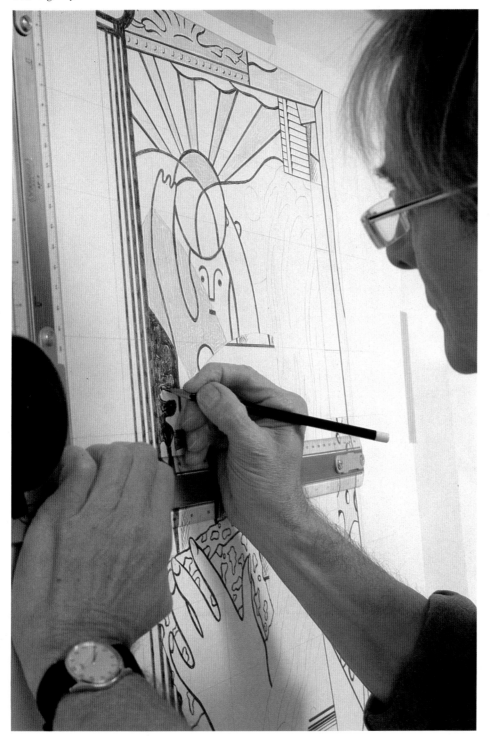

Roy tries to build a unified tonality. How to achieve this is a mystery. There are no rules for it. The kinds of colors can be awful but still have tonality, so the question is not one of pretty color. You could also get tonality by painting it all yellow, but diversity is preferable to Roy. He strives for a tonality where each color has to be that color and that size for the whole mural to work. Ideally, there is nothing arbitrary about either how bright or how big or where the color will be.

An artist does, however, want to achieve his or her tonality in a different way from any other artist. It is one of the artist's signatures. "I start going. I put some color down and then build on it. Something looks wrong. I change it. It's a hard thing. I don't think there is any way you can ever say how I am building a tonality."

Roy, who is fond of analogies to music, likens tonality to perfect pitch or knowing which notes go next. There may be some choice in the next note, because it depends on what has gone before and the character of the music. One composer has a sense that it will end on a particular chord, but another composer might select another chord. A sense of color is like that. Perhaps it is not the color that Rembrandt would have selected, and it probably is not the color that anyone else would have used. "I like making dissonances, like Stravinsky or Theolonius Monk."

89

Colored leaf

Collaged leaf

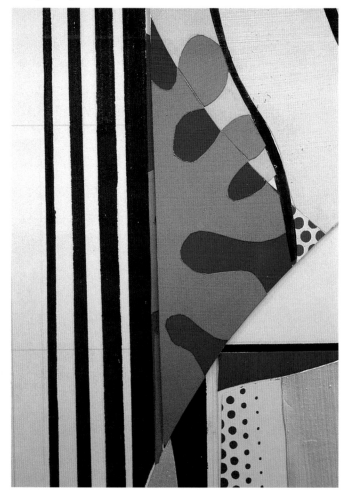

"Color is crucial in painting, but it is very hard to talk about. There is almost nothing you can say that holds up as generalization, because it depends on too many factors: size, modulation, the rest of the field, a certain consistency that color has with forms, and the statement you're trying to make."

Rejected elements

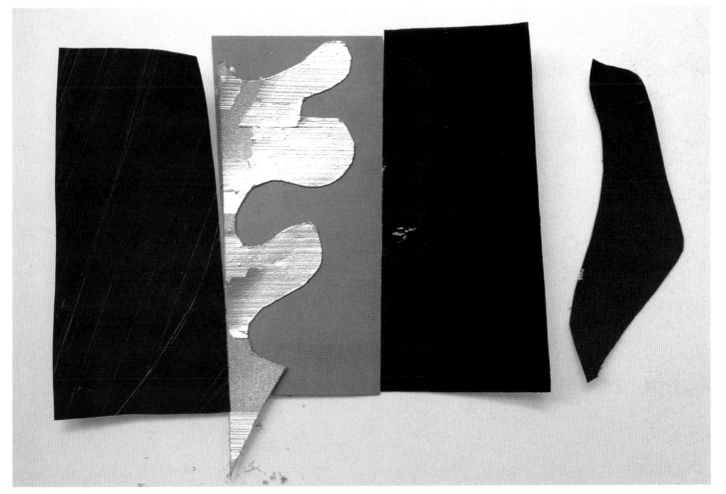

Colors are associated with subject
matter in Lichtenstein. Blue is sky,
green is grass, yellow is hair. It is
unusual in high art, but common in
naive art, to make such associations.
To propose such a use of color in
serious art is mischievous.

The Maquette

Two drawings of maquette

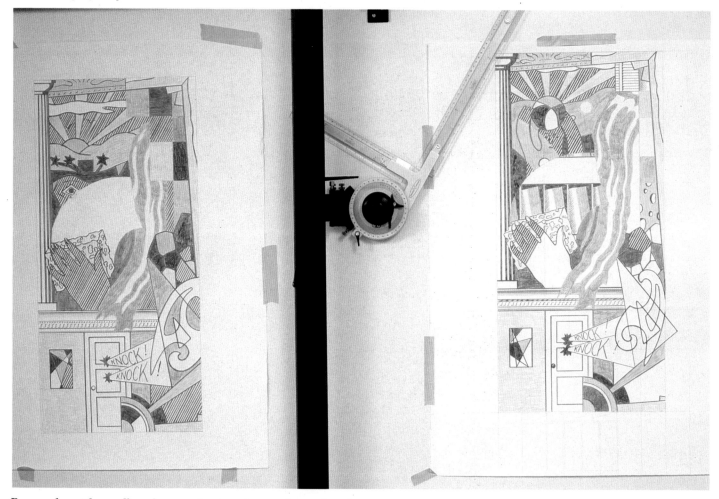

Roy works with a collage because it is instantly changeable. It gives shape and color at the same time. Because his work has no modulation, he paints the colors, cuts them, and puts them where he wants. Then he enlarges and projects on the canvas. Cut edges are more precise for enlargement.

Inking nearly complete version

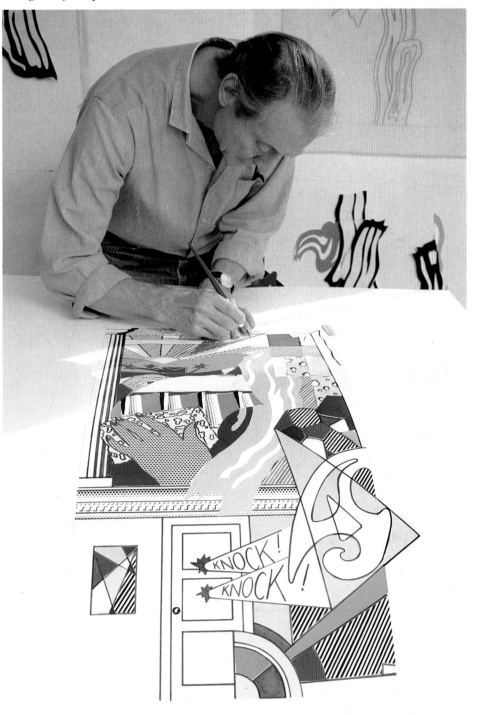

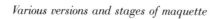
Various versions and stages of maquette

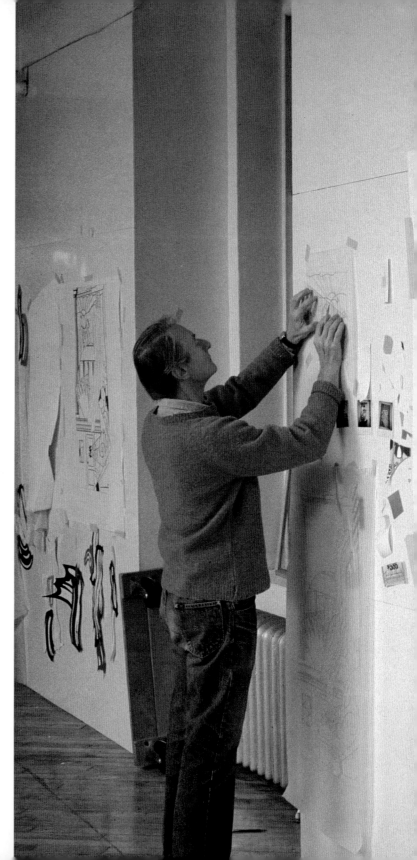

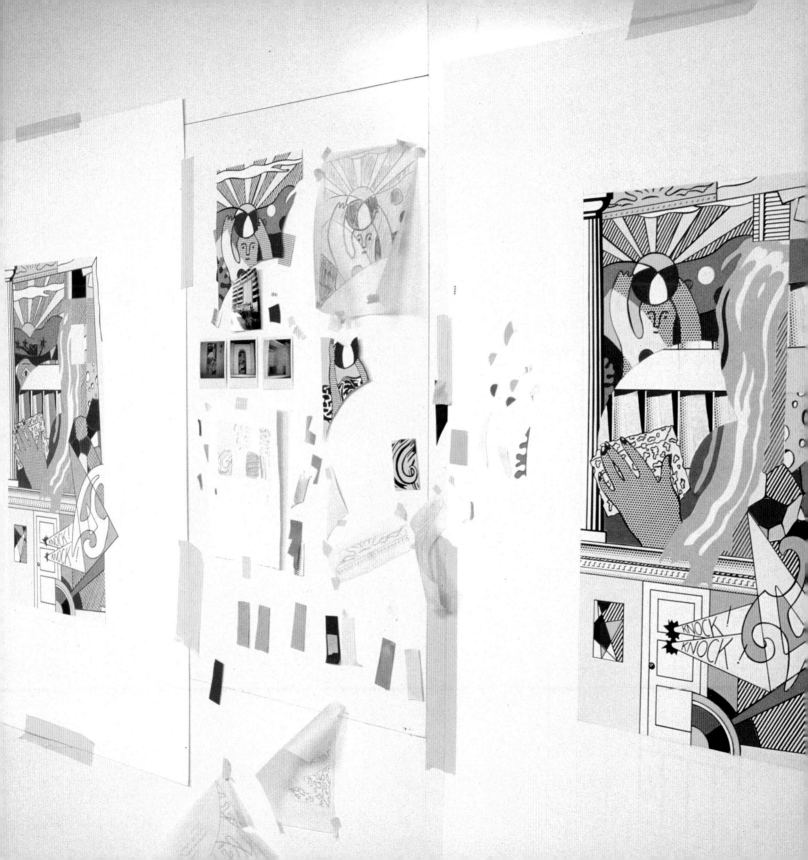

Roy mixes the color and consistency
that he wants. He puts at least two
coats of paint on everything, but
that depends on the covering power
of the paint. Sometimes he has to
use three coats of paint in order to
get coverage. White will definitely
be painted in three coats: Roy uses
two coats of Lascaux Gesso and one
coat of Lascaux white.

Approximately thirty gallons of
paint are used in the mural. The
paint here is thinner than usual,
because bigger, thicker brushes are
used and they will hold more paint.
Also, when you are painting large
areas, it is easier to paint thinner.

Magna is a turpentine-soluble
acrylic. Most acrylics are water-
based, but Roy thinks they look
waxy. He prefers magna because it
looks more like oil paint in the way
it shows color. Because magna is
soluble in turpentine, it can be
easily removed. Changes can be
made readily without revealing
texture. To avoid picking up the
underlayer—because magna is so
soluble in turpentine—an alcohol-
soluble varnish is used between
coats.

"I like the concept of using five
colors, like in cartoons. I'm going to
use eighteen or so in the mural. I've
gotten weak in my old age and have
decided to have certain subtleties,
even though I hate the idea."

97

The first large work that Lichtenstein undertook was for Philip Johnson's building at the World's Fair in 1964. He was living in New Jersey at the time and didn't have room for the painting in his studio, so he set it up against the front of the garage wall. People would stop and comment as he worked. "Oh, how nice." "You can paint a girl?"

"Early on I could see that some passersby immediately understood the humor of my work. Most just thought I was painting a billboard. I can always tell when someone takes me seriously—because they see that I'm having fun."

Equitable probably hadn't meant to have a mural in that space when the building was envisaged, or even after it was constructed, because when Lichtenstein came on the scene, the area was already faced with stone. This created a problem, because Roy had to figure out on what kind of surface he would paint the mural.

Removing the stone and perhaps plastering the area was considered, but Roy was afraid the plaster would have little cracks. Experts in stress and strain and in materials were called in. A restorer of paintings, Gerald Hopfner, was also consulted.

Plasterboard was considered, but had two problems. One was that at such a great size it would crack. A very tall surface is continuous with a very tall building, which will inevitably have movement. Also, plasterboard's surfaces are acid and will deteriorate, but plaster is also very alkaline and will neutralize the surface of the wallboard.

In the end, the canvas was attached with adhesive, which can be removed with difficulty. There are two major breaks, which means that the mural is in three areas. The two major divisions have an expansion joint in them. Over that, the canvas is slit. Since the slits occur in the entabla-

ture and window areas of the mural, Roy hopes that they won't be so obvious.

A heavy cotton duck was used. Roy usually paints on this material. Sizing and priming were done at the same time to cover the fiber so it would not absorb oil. Even though oil was not used, there will not be so much absorption. The texture will also hold the paint on.

Three slides of the maquette were then taken with cross hairs through them. One slide was of the top, one of the middle, and one of the base. The space on the mural was divided up with black photographer's tape in the same way so that the mural's cross hair could be matched up with the slide's cross hair. Drawing was done from a swing stage, and then painting from the scaffolding.

At the time, Roy said, "The scaffolding is going to make it hard to see the whole mural as we work. We thought about doing it from the swing stage. I feel secure on it. You'd have to try real hard to fall out. But I just don't think my hand is steady enough. We'll see . . ."

He added, "We'll be completely wiped out when we finish this work, but I'll run it like a military operation and I'm a good general—the Napoleon of painting!"

Work started a little late, because the building was not done. It was chilly inside and dusty, but Roy was glad to be working.

"The wall isn't prepared too well. I wanted my own assistant to paint the surface of the canvas, but I thought the job was too big for him, so I let the Equitable people do it. There is a lot of paint on the surface and it's bumpy. We will have to repaint. Maybe everything has to be painted again."

Mural surface being prepared

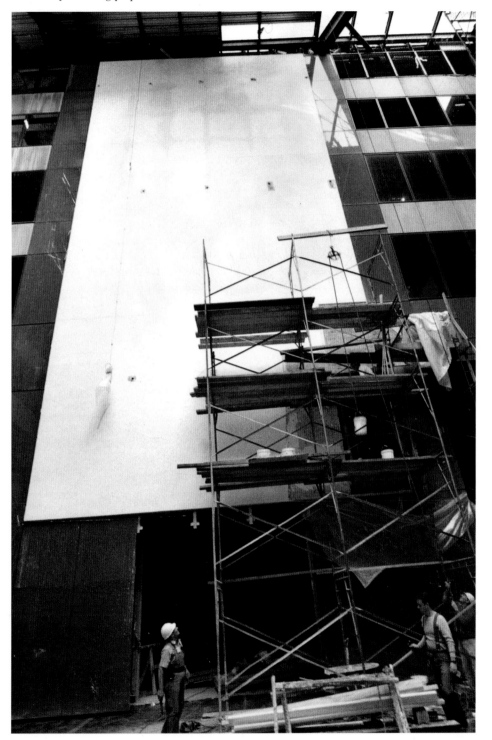

Projection of the Image

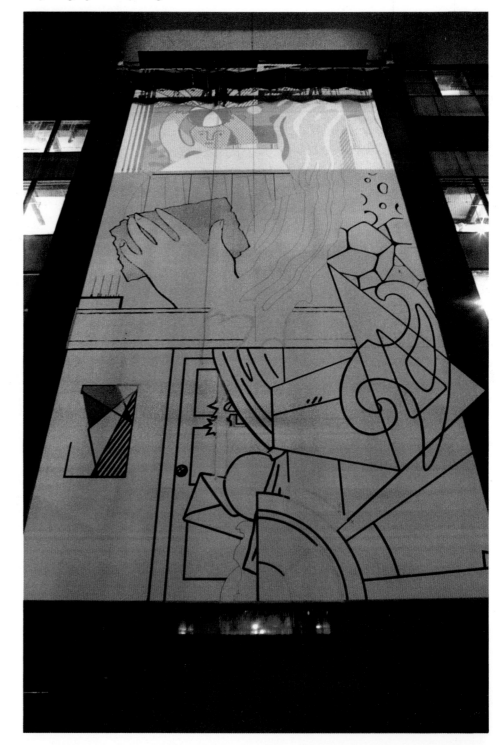

Projection has been used by painters for a long time to transfer material. Franz Kline drew on the yellow pages and then projected with an opaque projector. In the nineteenth century, people drew models through screens to flatten the image. Rather than project, some people draw grids and then make a proportionate grid on the wall. But here Roy really prefers to project. To do it any other way would take a great deal of time. The projection, drawing, and taping, in fact, took almost ten days.

102

Drawing and taping top third of mural

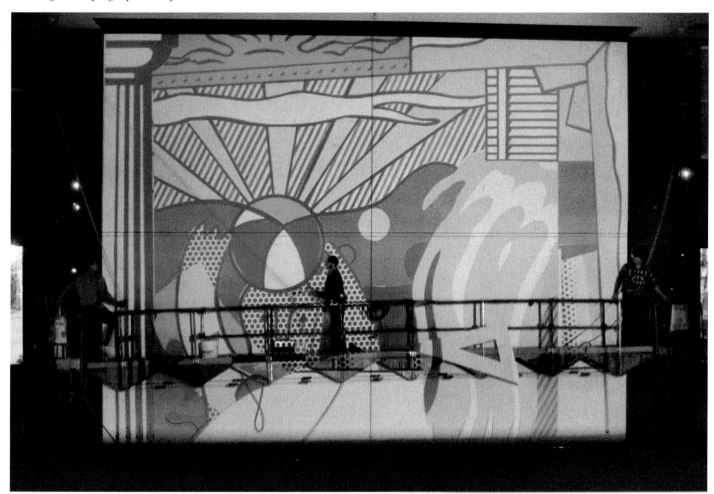

Realization of the Léger Face

Drawing eyebrow/nose

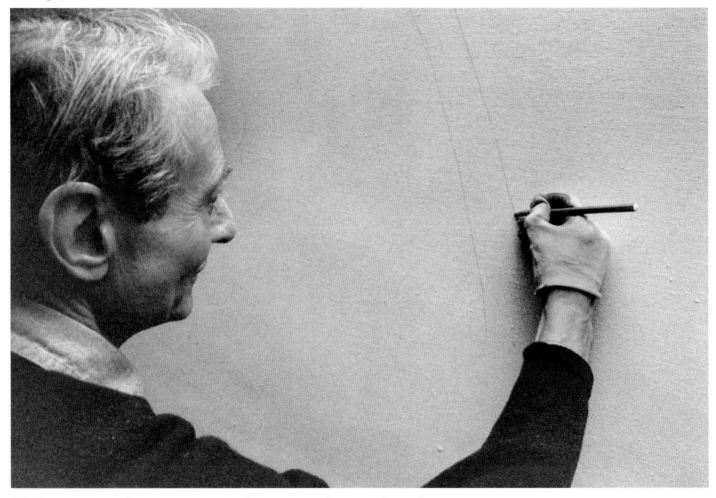

"We'll project using the swing stage because you can see through it. Once we've drawn the image in pencil and then in black tape so that it's visible from a distance, I can stand back, look at it, and make corrections. But once the scaffolding is constructed, it will just be there—all seventy feet of it. Then the whole team can work efficiently from it."

Drawing eye

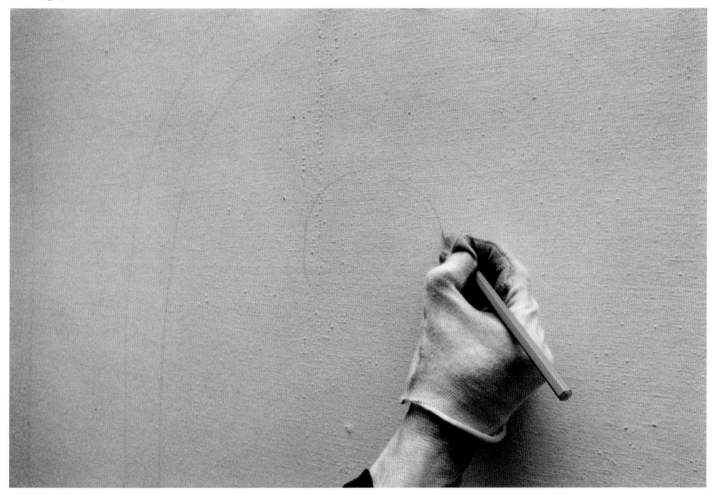

Taping face

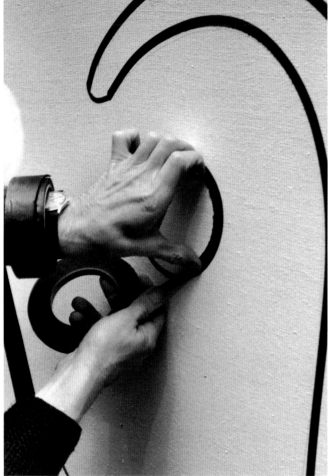

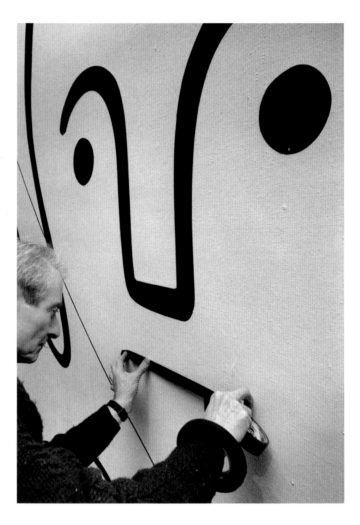

This area is taped so that it can be painted. After it is painted, the black tape is taken off and the line is taped. But before it is painted, the color on either side is done so that when the color leaks through, it will be the color and not the black.

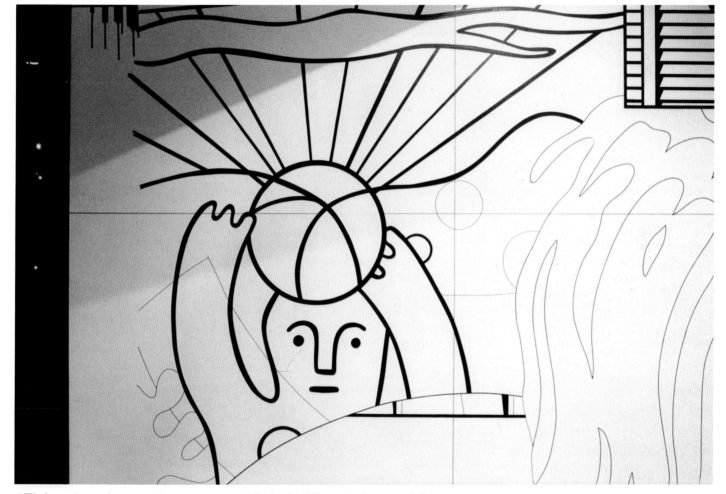

"We haven't made many changes. We changed the way the column on the left side went up. Or maybe it's the right side. I'm lysdexic. The windows did not line up, but we changed that while we were doing them. It was important for the windows in the mural to line up with the building windows, and the slide was not all that accurate."

Roy also changed the semicircle at the very bottom middle of the mural. He wanted it to look like a canopy over the existing door. As he taped, he made minor adjustments.

Taped and painted face

Roy has never done dots as big as this. That is because he has never done so large a work. His early paintings had extremely small dots which grew, even in relation to the scale. "When I started to work with dots, they were a comment on printing. Of course in printing, except for crude cartoon printing, the dots don't show. Here I use red dots as a symbol for flesh color."

Silk-screened Benday dots

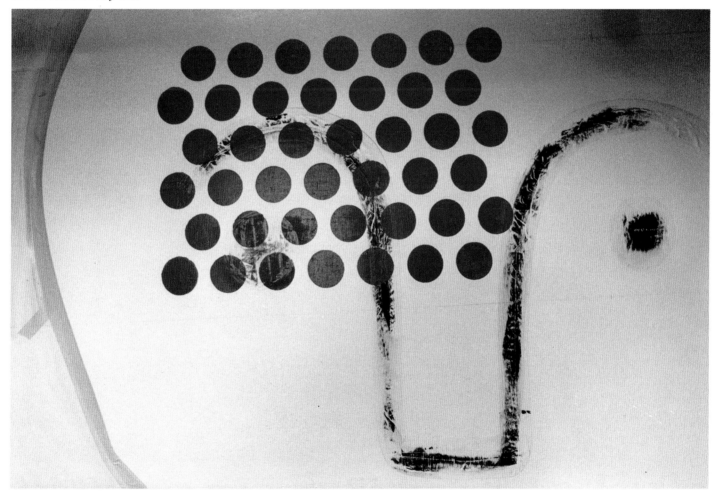

In the beginning, Roy used a stencil to make dots. Silk-screening is a different method, but the different processes do get similar results. "I have a feeling that the silk-screen dots will be more permanent than the printed-dot wallpaper I used in the GREENE STREET MURAL. I don't think I could stencil dots this big anyway."

Painting tapes and silk-screened face

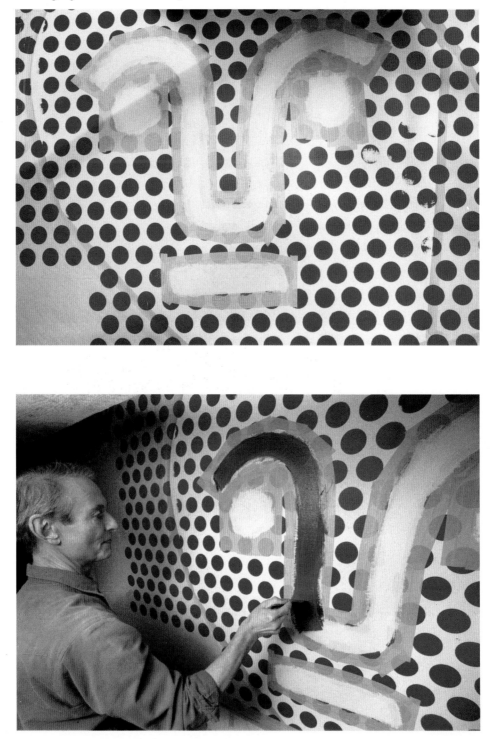

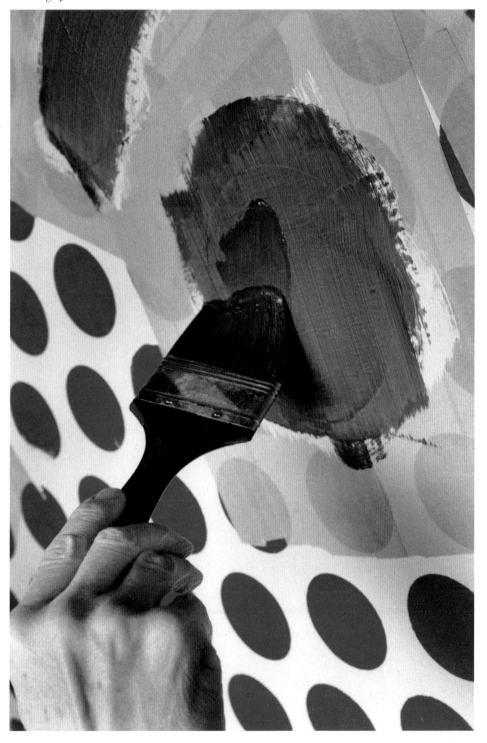

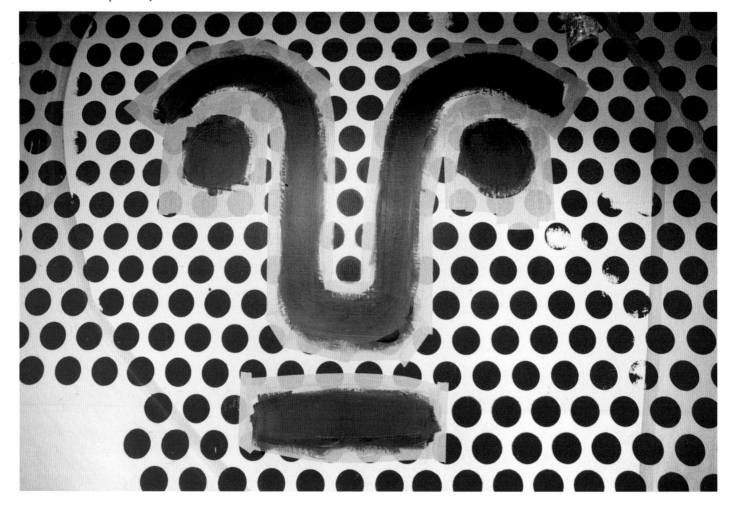

Silk-screened and painted face

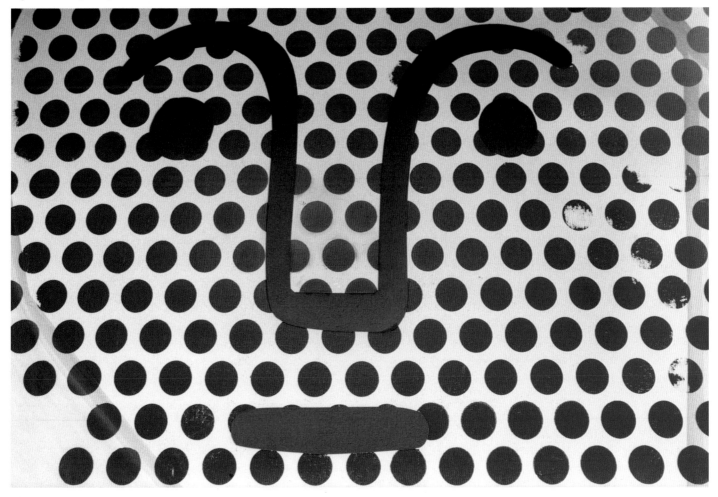

The Benday dots are one of Roy's trademarks, but that has never been his purpose in making them. "I always wanted to relate painting to printing. Dots are not an elegant European painting texture; they relate to a vernacular form of expression. If the dots are fifty percent red or blue or black, they represent a lack of nuance and speak to our times. It means that the painting is a fake. It's a repro- duction. At the same time, it's all dots and lines and color. It's abstract. I can see what the subject is doing, but I don't care."

Retouching Benday dots

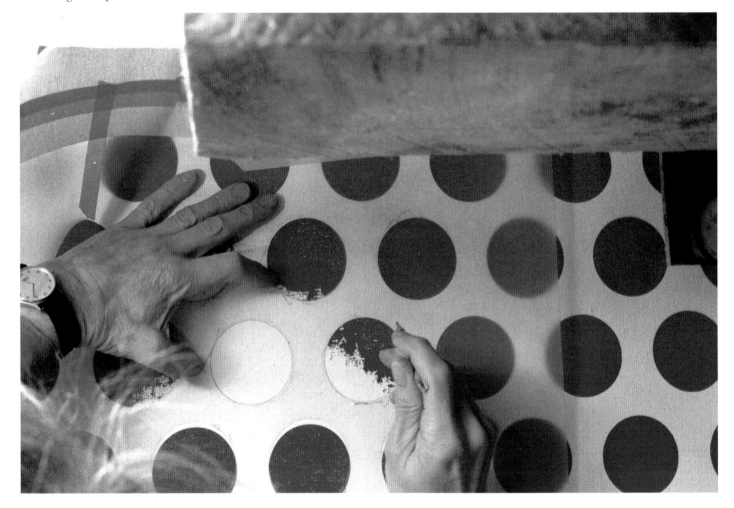

Retouching Benday dots

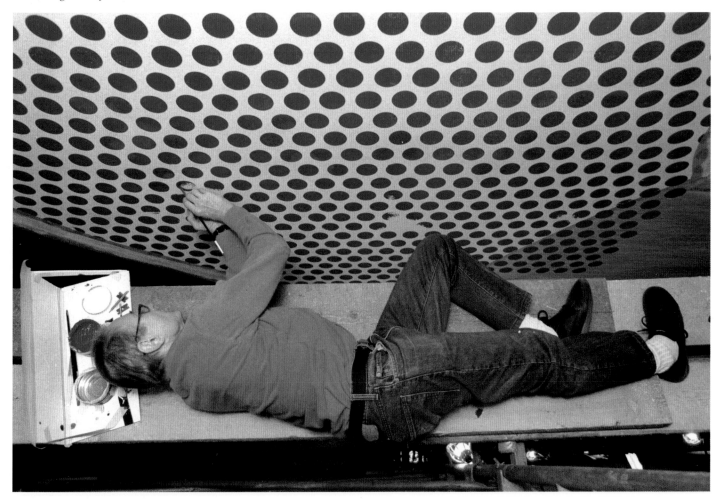

116

Pollock's and De Kooning's works were revolutionary and totally against what was going on. Now we see they were coming out of Cubism and Picasso, but then they seemed to be statements against European art. Pollock and De Kooning now *look* European and artistic to us. Roy's work doesn't look that artistic, but not many people doubt that it has a place in art.

Some Details

Painting taped entablature area

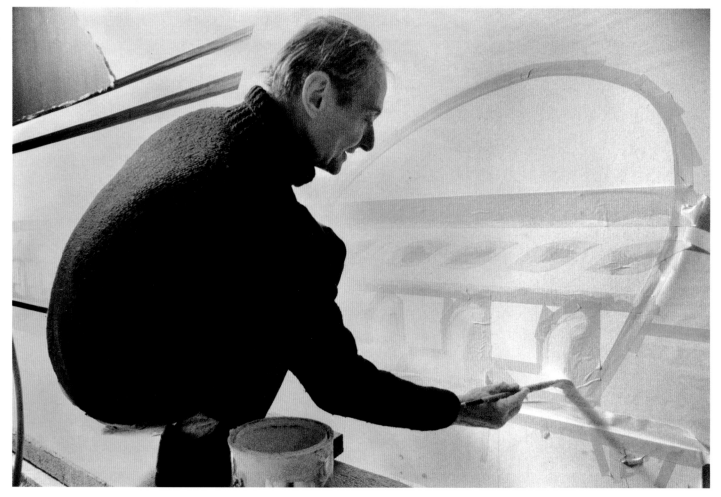

Roy's paintings make fun of emotions. The woman who is saying she could call for help is drowning. It's sad and it's funny. Funny because it's done in such a silly way. The emotion, if you really had it, wouldn't be funny, but the fact that he brings teenage comic-book style to it and calls it art and people collect it is funny to him.

Painting taped entablature area

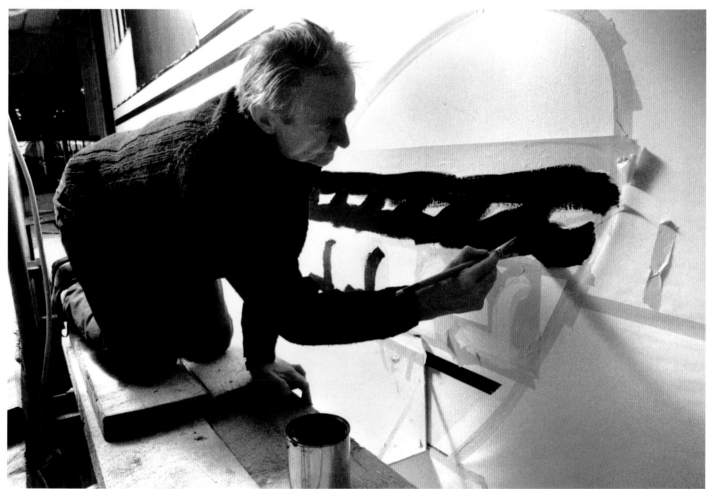

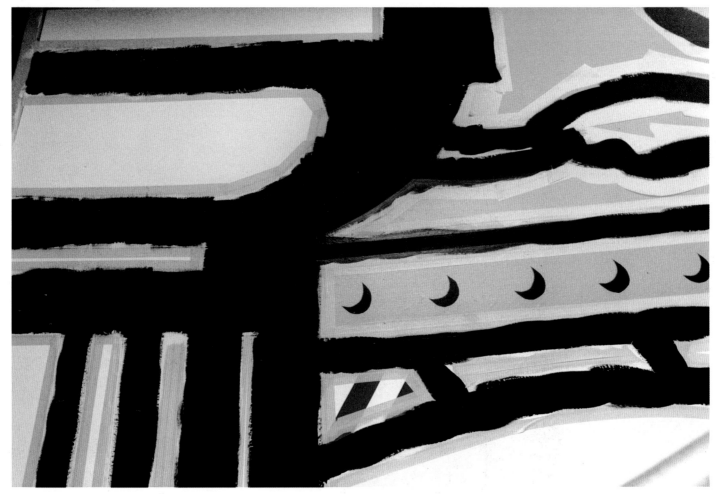

Comic books are highly emotional subject matter done by committee. Someone inks and someone fills in color and someone writes words. Comic books seem emotional but are depersonalized, which is also true of our other ways of communicating. That is what Roy is portraying. A lack of emotion. A lack of a personal touch.

Taped detail of philodendron leaf

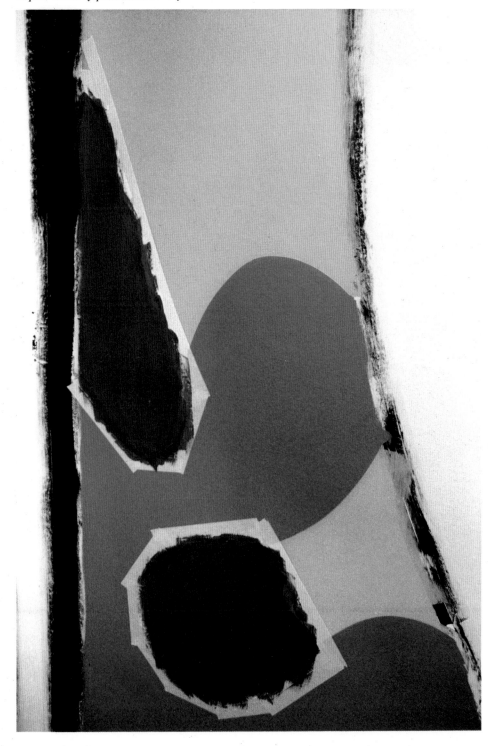

Taped detail of beach ball/sun

Roy observes, "My life began in an earlier, more personal, introspective time, which gives me insight into this alienated age. I think of my work as personal and emotional, but I like things to look as though they were done by the media and not by me."

"All my art is in some way about other art, even if the other art is cartoons."

Detail of painted flagstone

"At times the brushstroke looks like
a waterfall to me, but then it looks
as if someone threw a pail of water
out the window. That's why I call it
MURAL WITH BLUE BRUSHSTROKE.
So people won't get confused."

Detail of partially painted Art Deco area

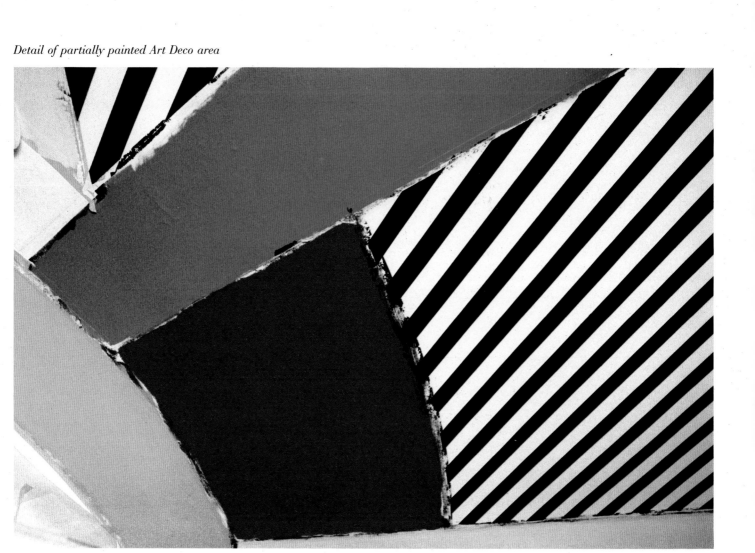

Retouching notebook area

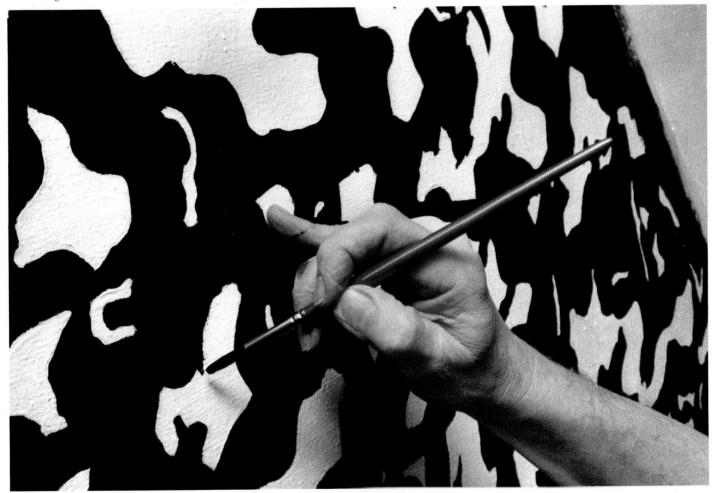

"Don't take anything I say too seriously. I just say anything that comes to my mind. You think it sounds funny at the moment. Or you think it sounds profound. It may have some truth to it. Everything is sort of a Rorschach where you can read into it what you want. Everything means something, but I just don't know what it means. It is difficult to translate art into words. Words will always fall short. It seems wrong to me when I reread it later. But not entirely wrong. In the end, you either see it or you don't."

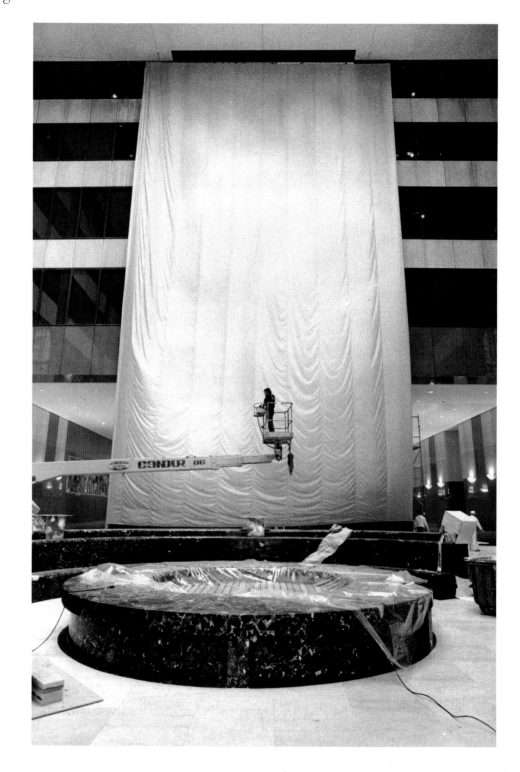

Roy poses in front of mural

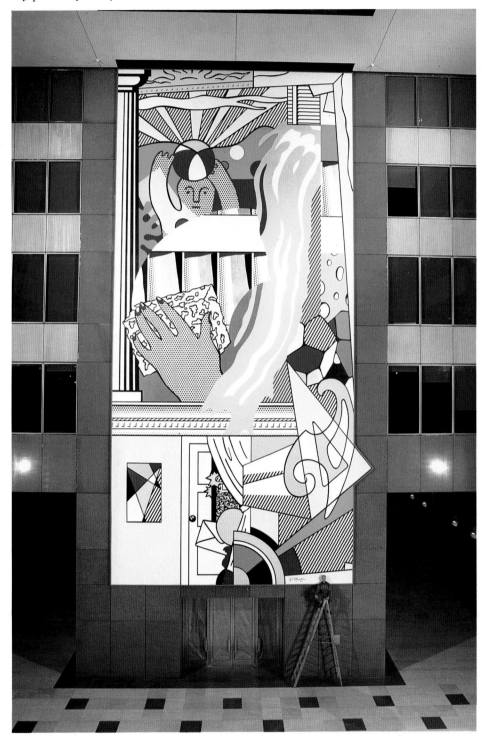

ACKNOWLEDGMENTS

You press the shutter alone, but this project would not be possible without the help, encouragement, and in some instances tolerance of many people. I would like to thank: Dorothy and Roy Lichtenstein, Olivia Motch, Rob McKeever, James de Pasquale, David Lichtenstein, Bryan O'Leary, Ben Holloway, Pari Choate, Jonathan Miller, Jerry Ordover, John Horan, John Loengard, Judith Daniels, Bob Ciano, Nora Sheehan, Marie Schumann, Deidre Wilson, Mary Simons, Todd Brewster, Peter Christopulos, Carmin Romanelli, Judy Twersky, Jane Gelb, Sally Henderson, Susan Hall, Doris Leath, Anne Yarowsky, and most particularly Sam Antupit "for bringing to bear his taste, intelligence and good humor."

Bob Adelman

The following individuals assisted Roy Lichtenstein in the realization of MURAL WITH BLUE BRUSH- STROKE: James de Pasquale (also on maquette), Rob McKeever (also on maquette), David Lichtenstein, Arch O'Leary, and Fernando Pomalaza; Olivia Motch was special assistant.

All photographs of the maquette and mural in process were taken by Bob Adelman. The remaining photographed works are reproduced herein with the permission of the following collections: page 8: (above left) Museum of Modern Art, New York, Gift of Philip Johnson, (below left) Private collection/photo courtesy Leo Castelli Gallery, New York, (right) Collection David Whitney (photo by Rudolph Burkhardt); page 9: (left) Collection Roy Lichtenstein/photo courtesy Leo Castelli Gallery, New York, (above right) Walker Art Center, Minneapolis, Minn./photo courtesy Leo Castelli Gallery, New York, (center right) Whitney Museum of American Art, New York, (below right) Museum of Modern Art, Frankfurt; page 11: Collection Equitable Real Estate Investment Management/photo © 1986 Bob Adelman; page 22: Collection Roy Lichtenstein/photo courtesy Leo Castelli Gallery, New York; page 24: Museum of Modern Art, New York, Philip Johnson Fund (by exchange) and gift of Mr. and Mrs. Bagley Wright; page 25: (left) Collection Richard Brown Baker/photo courtesy Leo Castelli Gallery, New York, (center) Collection Gagosian Gallery, New York/photo courtesy Leo Castelli Gallery, New York, (right) Collection Mr. and Mrs. Peter Brant, New York/photo courtesy Leo Castelli Gallery, New York; page 26: Collection Mr. Sy Newhouse, New York; page 28: (left) Collection City of Miami Beach, Fla./ photo courtesy Leo Castelli Gallery, New York, (right) Leo Castelli Gallery, New York (mural now plastered over)/photo © Bob Adelman; pages 30–31 (picture reproduction rights reserved by S.P.A.D.E.M. and A.D.A.G.P., Paris, where relevant): 1. Galerie Louise Leiris, Paris/photo © 1986 Bob Adelman, 2. photo by Gene Markowski, 4. photo © 1986 Bob Adelman, 5. photo © 1986 Bob Adelman, 6. La Jolla Collection of Contemporary Art, Gift of Mr. and Mrs. Robert Rowan, © Ellsworth Kelly, 1963, 8. photo © 1986 Bob Adelman, 9. Albright-Knox Art Gallery, Buffalo, N.Y., Room of Contemporary Art Fund, 1940, 10. Hirschhorn Museum and Sculpture Garden, Washington, D.C., 11. Kunstsammlung Nordrhein-Westfalen, Düsseldorf, 12. Private collection, 13. Private collection/photo courtesy Leo Castelli Gallery, New York, 14. photo © 1986 Bob Adelman, 15. Private collection/ photo by Eric Pollitzer, 16. Collection Philip Johnson, 18. The Seibu Museum of Art, Tokyo, 19. Collection Ileana and Michael Sonnabend, New York, 20. Private collection, 21. Collection Charles M. Senseman; page 32: Collection Equitable Real Estate Investment Management (photo © 1985 Schecter Lee).